NICOTEXT

NICOS DIRTY
MovieQuoteBook

It is the authors honest and sincere wish that this book will lead to an increased interest in film. We would also like to express our deepest gratitude towards filmproduction-companies, scriptwriters and actors. Without them this book would not excist.

If you find any wrongly quoted movies, or other mistakes PLEASE contact us and we will correct it in the next edition.

Respectfully, NICOTEXT

Fredrik Colting
Carl-Johan Gadd
Stefan Sjölander

© 2004 NICOTEXT
info@nicotext.com

Printed by: WS Bookwell, Finland. 2004

ISBN 91-974396-9-X

www.nicotext.com

"-Welcome to my submarine lair!
It's long, hard and full of seamen."

**AUSTIN POWERS
IN GOLDMEMBER**

Play the moviequiz game!

Rules:
There are six moviequotes on every right page.
The answers are on the following left page.
Use a dise and guess which movie the quotes are from.
Read one page each and pass the book on.
Note points on a piece of paper.
Play alone or with your friends!

RATED: PG

www.nicotext.com

1. "-I wish I had someone I could really respect.
-Hey, look at the cans on that bimbo!"

2. "-Once I stole a pair of red underwear from the department store. My mom wouldn't buy them for me... She said they were Satan's panties!"

3. "-Why do Chinese girls taste different from all other girls?
-You think we better, huh?
-No, just different. Like Peking Duck is different from Russian Caviar."

4. "-What did Manny Vasquez call you?
-"Bitch" mostly, but he meant it affectionately."

5. "-Now, what is the one thing if you put it in a movie it'll be successful?
-Tits."

6. "-I need a father who's a role model, not some horny geek-boy who's gonna spray his shorts every time I bring a girlfriend home from school."

ANSWER >

1. **BACHELOR PARTY**
 1984, USA
 Director: Neal Israel
 Actor: Tom Hanks, Tawny Kitaen, Adrian Zmed

2. **MISS CONGENIALITY**
 2000, USA
 Director: Donald Petrie
 Actor: Sandra Bullock, Michael Caine, Benjamin Bratt

3. **YOU ONLY LIVE TWICE**
 1967, UNITED KINGDOM
 Director: Lewis Gilbert
 Actor: Sean Connery, Akiko Wakabayashi, Tetsuro Tamba

4. **BASIC INSTINCT**
 1992, USA
 Director: Paul Verhoeven
 Actor: Michael Douglas, Sharon Stone, George Dzundza

5. **ED WOOD**
 1994, USA
 Director: Tim Burton
 Actor: Johnny Depp, Martin Landau, Sarah Jessica Parker

6. **AMERICAN BEAUTY**
 1999, USA
 Director: Sam Mendes
 Actor: Kevin Spacey, Annette Bening, Thora Birch

www.nicotext.com

1. "-Hello Lewis.
 -Hey Gilbert, did you find a house.
 -No, I met a girl though.
 -Gilbert.
 -Her name is Judy.
 -Judy is a nice name Gilbert.
 -Yea, she's a nice girl.
 -Big deal did you get in her pants.
 -She's not that kind of girl, Booger.
 -Why? Does she have a penis?"

2. "-Finally, a man that can satisfy two women at once!"

3. "-I was conceived in the back seat.
 -It's still sticky."

4. "-You brought me upstairs to show me your penis? How sweet!"

5. "-Are these questions testing whether I'm a replicant or a lesbian, Mr. Deckard?"

6. "-Luckily, I blocked her kick with my balls."

1. **REVENGE OF THE NERDS**
1984, USA
Director: Jeff Kanew
Actor: Robert Carradine, Anthony Edwards, Tim Busfield

2. **ROXANNE**
1987, USA
Director: Fred Schepisi
Actor: Steve Martin, Daryl Hannah, Rick Rossovich

3. **ST. ELMO'S FIRE**
1985, USA
Director: Joel Schumacher
Actor: Rob Lowe, Demi Moore, Andrew McCarthy

4. **VALENTINE**
2001, USA
Director: Jamie Blanks
Actor: Denise Richards, David Boreanaz, Marley Shelton

5. **BLADE RUNNER**
1982, USA
Director: Ridley Scott
Actor: Harrison Ford, Rutger Hauer, Sean Young

6. **HIGH STAKES**
1986, CANADA
Director: Larry Kent
Actor: Dave Foley, Roberta Weiss, Jackson Davies

1. "-Mitch, girl go pee-pee not something I want to see-see.
 -I agree-gree."

2. "-Does the female form make you uncomfortable, Mr. Lebowski?
 -Uh, is that what this is a picture of?
 -In a sense, yes. My art has been commended as being strongly
 vaginal which bothers some men. The word itself makes some
 men uncomfortable. Vagina.
 -Oh yeah?"

3. "-I like a girl in a bikini, no concealed weapons."

4. "-Golf requires concentration and focus.
 -Golf requires goofy pants and a fat ass. You should talk
 to my neighbor the accountant. Probably a great golfer.
 Huge ass."

5. "You have a girl. Unless I cut the wrong cord."

6. "-My friend told me this thing about men and sex,
 they think about it 238 times a day.
 -That's ridiculous, that would be about every 4 minutes...
 yeah, that's about right."

ANSWER >

1. **NOT ANOTHER TEEN MOVIE**
 2001, USA
 Director: Joel Gallen
 Actor: Chyler Leigh, Chris Evans, Jaime Pressly

2. **THE BIG LEBOWSKI**
 1998, USA
 Director: Joel Coen
 Actor: Jeff Bridges, John Goodman, Julianne Moore

3. **THE MAN WITH THE GOLDEN GUN**
 1974, UNITED KINGDOM
 Director: Guy Hamilton
 Actor: Roger Moore, Christopher Lee, Britt Ekland

4. **HAPPY GILMORE**
 1996, USA
 Director: Dennis Dugan
 Actor: Adam Sandler, Christopher McDonald, Julie Bowen

5. **NINE MONTHS**
 1995, USA
 Director: Chris Columbus
 Actor: Hugh Grant, Julianne Moore, Jeff Goldblum

6. **SIMPLY IRRESISTIBLE**
 1999, USA
 Director: Mark Tarlov
 Actor: Sarah Michelle Gellar, Sean Patrick Flanery,
 Patricia Clarkson

www.nicotext.com

1. "-For the experiment to be a success, all of the body parts
 must be enlarged.
 -His veins, his feet, his hands, his organs vould all have to
 be increased in size.
 -Exactly.
 -He vould have an enormous shwanstooker!
 -That goes without saying.
 -Voof!
 -He's going to be very popular."

2. "-I want to have sex with you!
 -Gulp! Couldn't you at least personalize it a little?
 -I want to have sex with you, Marilyn."

3. "-Just put your pickle on everybody's plate college boy and
 leave the hard stuff to me."

4. "-That chick could be a bigger disease carrier than the monkey
 in outbreak."

5. "-She has an arse that is so sexy, that I struggle to understand it."

6. "-I have a relationship with my phone. It's set to vibrate."

ANSWER >

1. **YOUNG FRANKENSTEIN**
 1974, USA
 Director: Mel Brooks
 Actor: Gene Wilder, Peter Boyle, Marty Feldman

2. **STARTING OVER**
 1979, USA
 Director: Alan J Pakula
 Actor: Burt Reynolds, Jill Clayburgh, Candice Bergen

3. **DIRTY DANCING**
 1987, USA
 Director: Emile Ardolino
 Actor: Jennifer Grey, Patrick Swayze, Jerry Orbach

4. **CHASING AMY**
 1997, USA
 Director: Kevin Smith
 Actor: Ben Affleck, Joey Lauren Adams, Jason Lee

5. **THREE TO TANGO**
 1999, USA
 Director: Damon Santostefano
 Actor: Matthew Perry, Neve Campbell, Dylan McDermott

6. **KEEPING THE FAITH**
 2000, USA
 Director: Edward Norton
 Actor: Edward Norton, Ben Stiller, Jenna Elfman

1. "-On my wedding night, my mother, she said to me, "Greek women, we may be lambs in the kitchen, but we are tigers in the bedroom."
 -EEw! Please let that be the end of your story."

2. "-Do you love her?
 -Kissed her butt, didn't I?"

3. "-Have you ever been with a girl, Forrest?
 -I see them in my Home economics class all the time."

4. "-Next time shit before you sign in. Shit! Sign in! In the car!
 -Am I gonna be tested on this later?"

5. "-A guy has two things in this world: his word and his balls. Or is that three things?"

6. "-Transfer of bodily fluids? Do you know what that leads to?
 -Yeah, I do! Smoking, kids, a desire to raid the fridge."

ANSWER >

1. **MY BIG FAT GREEK WEDDING**
 2001, USA
 Director: Joel Zwick
 Actor: John Corbett, Lainie Kazan, Michael Constantine

2. **A PERFECT WORLD**
 1993, USA
 Director: Clint Eastwood
 Actor: Kevin Costner, Clint Eastwood, Laura Dern

3. **FORREST GUMP**
 1994, USA
 Director: Robert Zemeckis
 Actor: Tom Hanks, Robin Wright, Gary Sinise

4. **KUFFS**
 1992, USA
 Director: Bruce Evans
 Actor: Christian Slater, Tony Goldwyn, Milla Jovovich

5. **DEEP COVER**
 1992, USA
 Director: Bill Duke
 Actor: Larry Fishburne, Jeff Goldblum, Victoria Dillard

6. **DEMOLITION MAN**
 1993, USA
 Director: Marco Brambilla
 Actor: Sylvester Stallone, Wesley Snipes, Sandra Bullock

www.nicotext.com

1. "-It's a teenage girl walking along the side of the highway.
 I mean, they, they, they make scary movies that start out
 like that.
 -Hey, but, but they make porno movies that start out like that
 too, man."

2. "-Are you suggesting madam that there exists a law compelling
 a gentleman to lay hold of canine bowel movements?
 -I'm suggesting that you pick the poop up."

3. "-I saw the way you were looking at my daughter's chest.
 -I used to be a cardiologist."

4. "-Now girls, have I ever told you the facts of life?
 -Oh, not this again.
 -Stay away from boys 'cause they are all disgusting,
 self-indulgent beasts that pee on bushes and pick their noses."

5. "-Remember my dear, they only want one thing.
 Maybe they want it more than once, but it's still only one thing."

6. "-I'll finish dressing.
 -Oh, please, don't. Not on my account."

ANSWER >

1. **DETROIT ROCK CITY**
 1999, USA
 Director: Adam Rifkin
 Actor: Edward Furlong, Guiseppe Andrews, James De Bello

2. **KATE & LEOPOLD**
 2001, USA
 Director: James Mangold
 Actor: Meg Ryan, Hugh Jackman, Liev Schreiber

3. **OUT TO SEA**
 1997, USA
 Director: Martha Coolidge
 Actor: Jack Lemmon, Walter Matthau, Dyan Cannon

4. **THE PRINCE OF TIDES**
 1991, USA
 Director: Barbra Streisand
 Actor: Barbra Streisand, Nick Nolte, Blythe Danner

5. **A LIFE LESS ORDINARY**
 1997, UNITED KINGDOM
 Director: Danny Boyle
 Actor: Ewan McGregor, Kirk Cameron, Magaret Colin

6. **DIAMONDS ARE FOREVER**
 1971, UNITED KINGDOM
 Director: Guy Hamilton
 Actor: Sean Connery, Jill St. John, Charles Gray

1. "-Can I ask you a personal question?
 -Sure.
 -You ever get an erection over a woman?
 -Melvin...
 -I mean, wouldn't your life be easier if you weren't...?
 -You consider your life easy?
 -All right, I give you that one."

2. "-Do you believe this man asking whether my Teresa would fool around?
 -I find it hard to imagine your wife sleeping with YOU."

3. "-How tall are you without your horse?
 -Well ma'am, I'm six feet seven inches.
 -Never mind the six feet, let's talk about the seven inches."

4. "-I've been to gold towns, silver towns, I've even been to turquoise towns. But I have never been to a bat shit town. Can't wait to see the women!"

5. "-Some men are longer than others.
 -Your mother's been telling stories about me again, ah?"

6. "-My brain! It's my second favourite organ."

ANSWER >

1. **AS GOOD AS IT GETS**
 1997, USA
 Director: James L Brooks
 Actor: Jack Nickolson, Helen Hunt, Greg Kinnear

2. **WOMAN IN RED**
 1984, USA
 Director: Gene Wilder
 Actor: Gene Wilder, Kelly LeBrock, Glida Radner

3. **MYRA BRECKENRIDGE**
 1970, USA
 Director: Michael Sarne
 Actor: Mae West, John Huston, Raquel Welch

4. **YOUNG GUNS II**
 1990, USA
 Director: Geoff Murphy
 Actor: Emilio Esteves, Kiefer Sutherland,
 Lou Diamond Phillips

5. **BRAVEHEART**
 1995, USA
 Director: Mel Gibson
 Actor: Mel Gibson, Sophie Marceau, Patrick McGoohan

6. **SLEEPER**
 1973, USA
 Director: Woody Allen
 Actor: Woody Allen, Diane Keaton, John Beck

www.nicotext.com

1. "-So two guys you were best friends with in law school fell in love with each other?
 -Yeah.
 -Is that strange for you?
 -Uh, nothing changed really. They watch a different kind of porno now."

2. "-What do you look for in a woman you date?
 -Well, I know everyone always says sense of humor, but I'd really have to go with breast size."

3. "-Hey, is it OK if I put this down, I'm getting tired of holding it.
 -Yeah, that's what she said."

4. "-Your request is not unlike your lower intestine: stinky and loaded with danger."

5. "-Can I do this, or will I look like some sort of gay superhero?"

6. "-Wait a minute, did you just grab my ass?
 -No.
 -Do you want to?
 -No... Should I?"

ANSWER >

1. **BIG DADDY**
 1999, USA
 Director: Dennis Dugan
 Actor: Adam Sandler, Joey Lauren Adams, Rob Schneider

2. **SO I MARRIED AN AXE MURDERER**
 1993, USA
 Director: Thomas Schlamme
 Actor: Mike Myers, Nancy Travis, Anthony La Paglia

3. **WAYNE'S WORLD**
 1992, USA
 Director: Penelope Spheeris
 Actor: Mike Myers, Dana Carvey, Rob Lowe

4. **ACE VENTURA: WHEN NATURE CALLS**
 1995, USA
 Director: Steve Oedekerk
 Actor: Jim Carrey, Ian Mcneice, Simon Callow

5. **JEFFREY**
 1995, USA
 Director: Christopher Ashley
 Actor: Steven Weber, Michael T Weiss, Patrick Stewart

6. **A NIGHT AT THE ROXBURY**
 1998, USA
 Director: John Fortenberry
 Actor: Will Ferrell, Chris Kattan, Molly Shannon

1. "-Is he still there?
 -You must be joking! Double-0 seven on an island populated exclusively by women? We won't see him till dawn!"

2. "-Do you know of Dr. Freud, Mr. Ismay? His ideas of the male preoccupation with size might be of particular interest to you."

3. "-Goose who's butt did you kiss to get in here anyway?
 -The list is long, but distinguished.
 -Yeah, well so is my Johnson."

4. "-I know I'm old enough to be his mother, but when the Duck laid that kiss on me last night, I swear my thighs just went up in flames! He must practice on melons or something."

5. "-Check out the funbags on that hosehound.
 -I'd like to eat her liver with some fava beans and a bottle of Chianti."

6. "-A ladies' man, eh?
 -The problem is, I've got a fifty year old lust but a three year old dinky."

ANSWER >

1. OCTOPUSSY
 1983, UNITED KINGDOM
 Director: John Glen
 Actor: Roger Moore, Maud Adams, Louis Jourdan

2. TITANIC
 1997, USA
 Director: James Cameron
 Actor: Leonardo Di Caprio, Kate Winslet, Billy Zane

3. TOP GUN
 1986, USA
 Director: Tony Scott
 Actor: Tom Cruise, Kelly McGillis, Val Kilmer

4. PRETTY IN PINK
 1986, USA
 Director: Howard Deutch
 Actor: Molly Ringwald, Jon Cryer, Andrew McCarthy

5. DUMB & DUMBER
 1994, USA
 Director: Peter Farrelly
 Actor: Jim Carrey, Jeff Daniels, Lauren Holly

6. WHO FRAMED ROGER RABBIT
 1988, USA
 Director: Robert Zemeckis
 Actor: Bob Hoskins, Christopher Lloyd, Joanna Cassidy

1. "-Hey, guys. Do you know where I can find the clitoris?
 -The what?
 -What, is that like finding Jesus or something?"

2. "-This? This is ice. This is what happens to water when it gets too cold. This? This is Kent. This is what happens to people when they get too sexually frustrated."

3. "-I want a grandchild.
 -Well, Ma, you'll be happy to know that I am looking into having some eggs frozen.
 -Wonderful. I can tell everyone I'm having a grandsicle."

4. "-Now, in my native land, we used to bang on drums to communicate to the other tribes. With these lady's breasts, we could communicate all the way to Baton Rouge!"

5. "-How do you like your eggs in the morning, scrambled or fertilized?"

6. "-I got a hot date.
 -Yeah? Who is she and what did you arrest her for?"

ANSWER >

1. **SOUTH PARK: BIGGER, LONGER & UNCUT**
 1999, USA
 Director: Trey Parker
 Voices: Trey Parker, Matt Stone, Mary Kay Bergman

2. **REAL GENIUS**
 1985, USA
 Director: Martha Coolidge
 Actor: Val Kilmer, Gabe Jarret, Michelle Meyrink

3. **PICTURE PERFECT**
 1997, USA
 Director: Glenn Gordon Caron
 Actor: Jennifer Aniston, Jay Mohr, Kevin Bacon

4. **WILD WILD WEST**
 1999, USA
 Director: Barry Sonnenfeld
 Actor: Will Smith, Kevin Kline, Kenneth Branagh

5. **200 CIGARETTES**
 1999, USA
 Director: Risa Bramon Garcia
 Actor: Ben Affleck, Casey Affleck, Dave Chapelle

6. **L.A. CONFIDENTIAL**
 1997, USA
 Director: Curtis Hanson
 Actor: Kevin Spacey, Russel Crowe, Guy Pearce

1. "-The last guy that made fun of my hair is still trying to pull his head outta his ass.
 -I dont want to know about your personal life."

2. "-It must be interesting to be in a room full of men, most of whom you've seen with their pants down.
 -Puts it all in some kind of perspective."

3. "-Okay Dennis, look at it this way: a new furniture arrangement is like a new hairstyle, you have to live with it for a few days before you can tell whether you really like it or not.
 -That is not true. I haven't had a shag, but I wouldn't have to live with one for a few days to know that I don't want one."

4. "-Mary... I desperately want to make love to a school-boy."

5. "-You have great hands. I could use someone like you on my staff.
 -My hands aren't going anywhere near your staff."

6. "-The only thing I'll ever lay is a rug!"

ANSWER >

1. **DOUBLE TEAM**
 1997, USA
 Director: Tsui Hark
 Actor: Jean-Claude Van Damme, Dennis Rodman,
 Mickey Rourke

2. **DANGEROUS BEAUTY**
 1998, USA
 Director: Marshall Herskovitz
 Actor: Catherine McCormack, Rufus Sewell,
 Jaqueline Bissett

3. **THE BROKEN HEARTS CLUB: A ROMANTIC COMEDY**
 2000, USA
 Director: Greg Berlanti
 Actor: Timothy Olyphant, Zach Braff, Dean Cain

4. **DUMB & DUMBER**
 1994, USA
 Director: Peter Farrelly
 Actor: Jim Carrey, Jeff Daniels, Lauren Holly

5. **CHARLIE'S ANGELS**
 2000, USA
 Director: Joseph McGinty Nicol
 Actor: Cameron Diaz, Drew Barrymore, Lucy Liu

6. **ROCK N' ROLL HIGH SCHOOL**
 1979, USA
 Director: Allan Arkush, Joe Dante
 Actor: P.J. Soles, Vincent Van Patten, Clint Howard

1. "-But Mom, seriously, doesn't designing all these wedding gowns ever make you think about getting married... Or maybe just think about the "F" word?
 -The "F" word?!
 -My father.
 -Oh. That "F" word."

2. "-Oh, it's alright. I'm sure that we can handle this situation maturely, just like the responsible adults that we are. Isn't that right, Mr... Poopy Pants?"

3. "-I am the gangster of love.
 -Gangster, huh? So tell me, was it more of a hold up than a stick up?
 -Even your infantile penis jokes seem funny and witty this morning."

4. "-Your breasts, they're like melons. No, no, they're like pillows. Can I fluff your pillows?"

5. "-Wow, Awesome! They got porno!"

6. "-You've already stolen my heart... As well as another more prominent organ, south of the Equator."

 ANSWER >

1. **THE PARENT TRAP**
 1998, USA
 Director: Nancy Myers
 Actor: Lindsay Lohan, Dennis Quaid, Natasha Richardson

2. **THE NAKED GUN 2 1/2: THE SMELL OF FEAR**
 1991, USA
 Director: David Zucker
 Actor: Leslie Nielsen, Priscilla Presley, George Kennedy

3. **GRUMPIER OLD MEN**
 1995, USA
 Director: Howard Deutch
 Actor: Jack Lemmon, Walter Matthau, Ann Margret

4. **ROXANNE**
 1987, USA
 Director: Fred Schepisi
 Actor: Steve Martin, Daryl Hannah, Rick Rossovich

5. **BULLETPROOF**
 1996, USA
 Director: Ernest Dickerson
 Actor:: Adam Sandler, Damon Wyans, James Caan

6. **QUILLS**
 2000, USA
 Director: Philip Kaufmann
 Actor: Geoffrey Rush, Kate Winslet, Joaquin Phoenix

1. "-OK, I'll go. I was getting a bit choked up with all the testosterone flying about the place. Best I get out before I start growing a penis."

2. "-And he said 'Baby, up your butt with a coconut!
Except.. There was no coconut.
He didn't have a coconut to my knowledge."

3. "-How was your day?
-Not great. A nurses's day is always pretty grisly. A woman I was with gave birth to a baby in a lift.
-Well, that was okay, er?
-It would have been, but her husband slipped on the afterbirth and broke his collarbone."

4. "-Remember, there are 6127 students at Adams,
58% of which are girls.
-So, that's 7107,32 boobs."

5. "-So what do you way, like 110? 115?
-Which one of my butt cheeks are you talking about?"

6. "-Oh the things I do for England."

ANSWER >

1. **SLIDING DOORS**
 1998, USA/UNITED KINGDOM
 Director: Peter Howitt
 Actor:: Gwyneth Paltrow, John Hannah, John Lynch

2. **QUICK CHANGE**
 1990, USA
 Director: Howard Franklin, Bill Murray
 Actor: Bill Murray, Geena davis, Randy Quaid

3. **THE TALL GUY**
 1989, UNITED KINGDOM
 Director: Mel Smith
 Actor: Jeff Goldblum, Emma Thompson, Rowan Atkinson

4. **REVENGE OF THE NERDS**
 1984, USA
 Director: Jeff Kanew
 Actor: Robert Carradine, Anthony Edwards, Tim Busfield

5. **SHALLOW HAL**
 2001, USA
 Director: Bobby Farrelly, Peter Farrelly
 Actor: Gwyneth Paltrow, Jack Black, Jason Alexander

6. **YOU ONLY LIVE TWICE**
 1967, UNITED KINGDOM
 Director: Lewis Gilbert
 Actor: Sean Connery, Akiko Wakabayashi, Tetsuro Tamba

www.nicotext.com

1. "-You know what I think?
 -No, what?
 -I think you have a big honkin booger hanging out of your left nostril and you should use this finger to pick it out!"

2. "-Around me, if a girl don't wear fur, she don't wear nuttin'.
 -Well, I look good both ways."

3. "-You know what the most difficult part of being you is? Pretending to be so bad in bed."

4. "-Could you pass me the towel, please?
 -Sure, sorry.
 -Just pretend I'm your sister.
 -I have two sisters. They don't look like you."

5. "-Well, Muzz, I guess it's just you, and... And me... And your balls... And this drawer."

6. "-What's that?
 -Sushi.
 -Sushi??
 -Rice, raw fish, and seaweed.
 -You won't accept a guy's tongue in your mouth, and you're going to eat that?"

ANSWER >

1. **TANK GIRL**
 1995, USA
 Director: Rachel Talalay
 Actor:Lori Petty, Ice-T, Naomi Watts

2. **DICK TRACY**
 1990, USA
 Director: Warren Beatty
 Actor:Warren Beatty, Madonna, Al Pacino

3. **THE SAINT**
 1997, USA
 Director: Philip Noyce
 Actor: Val Kilmer, Elisabeth Shue, Rade Serbedzija

4. **RED PLANET**
 2000, USA
 Director: Anthony Hoffman
 Actor: Val Kilmer, Carrie Ann Moss, Tom Sizemore

5. **DRAGNET**
 1987, USA
 Director: Tom Mankiewicz
 Actor: Dan Aykroyd, Tom Hanks, Christopher Plummer

6. **THE BREAKFAST CLUB**
 1985, USA
 Director: John Hughes
 Actor: Emilio Esteves, Judd Nelson, Molly Ringwald

www.nicotext.com

1. "-I got a job at the striptease. I help the girls dress and undress.
 -Nice job.
 -Twenty francs a week.
 -Not very much.
 -It's all I can afford."

2. "-I, ah... I can only play G-rated movies.
 -Oh well, there's nothing wrong with G-rated movies,
 as long as there's lots of sex and violence."

3. "-As long as there's you know, sex and drugs, I can do without
 the rock 'n' roll."

4. "-You know, when it's hot like this... You know what a do?
 I keep my undies in the icebox."

5. "-I think sex is like supermarkets, you know, overrated.
 Just a lot of pushing and shoving and you still come
 out with very little at the end."

6. "-That figures. All pricks move to California.
 They should just call it prickafornia."

ANSWER >

1. WHAT'S NEW PUSSYCAT?
 1965, USA
 Director: Clive Donner
 Actor: Peter Sellers, Peter O'Toole, Romy Schneider

2. ELVIRA MISTRESS OF THE DARK
 1988, USA
 Director: James Signorelli
 Actor: Cassandra Peterson, William Morgan Sheppard,
 Daniel Greene

3. THIS IS SPINAL TAP
 SPINAL TAP, 1984, USA
 Director: Rob Reiner
 Skådespelare: Michael McKean, Christopher Guest, Harry Shearer

4. THE SEVEN YEAR ITCH
 1955, USA
 Director: Billy Wilder
 Actor: Marilyn Monroe, Tom Ewell, Evelyn Keyes

5. SHIRLEY VALENTINE
 1989, UNITED KINGDOM
 Director: Lewis Gilbert
 Actor: Pauline Collins, Tom Conti, Alison Steadman

6. WHERE THE HEART IS
 2000, USA
 Director: Matt Williams
 Actor: Natalie Portman, Ashley Judd, Stockard Channing

1. "-Wow, thanks coming from you that's a huge compliment.
 You used to hold the collage record for the most penis in
 a single season.
 -Um, so you have all my stats?
 -Yeah, I'm a huge fan, I used to have that poster of you...
 Did I say penis back there.
 -Yes you did, but I let it slide."

2. "-Let me tell you something, I don't know anything about that,
 so you can kiss my fat ass.
 -Clive, it would take me all day to kiss your fat ass."

3. "-I know that Richard will always be faithful to me.
 -That's nice. Trust.
 -Fear of herpes."

4. "-What is a sex crime.
 -Not getting any!"

5. "-Ow! Doesn't that hurt them?
 -Doesn't seem to.
 -Well, it would bruise the hell out of me."

6. "-Woman with large breasts... woman with small breasts...
 -hey, this one looks kinda like you... with breasts."

 ANSWER >

1. **THREE TO TANGO**
1999, USA
Director: Damon Santostefano
Actor: Matthew Perry, Neve Campbell, Dylan McDermott

2. **RUSH HOUR**
1998, USA
Director: Brett Ratner
Actor: Jackie Chan, Chris Tucker, Elizabeth Pena

3. **THE BIG CHILL**
1983, USA
Director: Lawrence Kasdan
Actor: Tom Berenger, Glenn Close, Jeff Goldblum

4. **WILD THINGS**
Actor:1998, USA
Director: John McNaughton
Actor: Kevin Bacon, Matt Dillon, Neve Campbell

5. **A LEAGUE OF THEIR OWN**
1992, USA
Director: Penny Marshall
Actor: Tom Hanks, Geena Davis, Madonna

6. **ARMAGEDDON**
1998, USA
Director: Michael Bay
Actor: Bruce Willis, Billy Bob Thornton, Liv Tyler

1. "-I took a Viagra and it got stuck in my throat and I've had a stiff neck ever since."

2. "-Johnny was the only guy who could out-disgust me. When we were kids we had gross-out contests. I coughed a pile of phlegm on a table, he said "Nice try!" and pulled out a straw..."

3. "-Can I sleep in your room, Buzz? -I wouldn't let you sleep in my room if you were growing on my ass!"

4. "-I suspect that your version of romance is whatever will separate me from my panties. -No, I am just talking about dinner. Wear make-up, put on a dress. Panties are optional."

5. "-If God wanted us to walk around naked, he wouldn't have invented fig leaves, or cotton and polyester."

6. "-Wow, Angela. You look different. What happened? -I'm dressed."

ANSWER >

1. AUSTIN POWERS IN GOLDMEMBER
 2002, USA
 Director: Jay Roach
 Actor: Mike Myers, Michael Caine, Beyonce Knowles

2. THE ADVENTURES OF FORD FAIRLANE
 1990, USA
 Director: Renny Harlin
 Actor: Andrew Dice Clay, Wayne Newton, Priscilla Presley

3. HOME ALONE
 1990, USA
 Director: Chris Columbus
 Actor: Macaulay Culkin, Joe Pesci, Daniel Stern

4. DOC HOLLYWOOD
 1991, USA
 Director: Michael Caton Jones
 Actor: Michael J Fox, Julie Warner, Bridget Fonda

5. SEX FILES: SEXUALLY BEWITCHED
 1999, USA
 Director: Mindy DeBaise
 Actor: Amber Newman, Michelle Hall, Johnny Quaid

6. THREE MEN AND A BABY
 1987, USA
 Director: Leonard Nimoy
 Actor: Tom Selleck, Steve Guttenberg, Ted Danson

1. "-Walter, just stand outside so Chief can translate my Iraqi ass map... Okay?"

2. "-...and that, my liege,
 is how we know the Earth to be banana shaped.
 -This new learning amazes me, Sir Bedevere. Explain again how sheep's bladders may be employed to prevent earthquakes."

3. "-How would you like your steaks cooked?
 -Oh, just knock its horns off, wipe its nasty ass,
 and chunk it right here on this plate."

4. "-What's this I hear about you doing laundry with my sister?
 -Did she say we were doing laundry? Because where I come from, it's called "doing the hibbidy-dibbidy.""

5. "-You know how a women gets a man excited?
 She shows up. That's it. We're guys, we're easy."

6. "-Come on class say it with me.
 - Penis, penis, penis, vagina, vagina, vagina.
 -Penis, penis, penis, vagina, vagina, vagina."

ANSWER >

1. THREE KINGS
 1999, USA
 Director: David O Russell
 Actor: George Clooney, Mark Wahlberg, Ice Cube

2. MONTY PYTHON AND THE HOLY GRAIL
 1975, UNITED KINGDOM
 Director: Terry Jones, Terry Gilliam
 Actor: Graham Chapman, John Cleese, Terry Gilliam

3. THE COWBOY WAY
 1994, USA
 Director: Gregg Champion
 Actor: Woody Harrelson, Kiefer Sutherland, Ernie Hudson

4. BIG DADDY
 1999, USA
 Director: Dennis Dugan
 Actor: Adam Sandler, Joey Lauren Adams, Rob Schneider

5. SIX DAYS AND SEVEN NIGHTS
 1998, USA
 Director: Ivan Reitman
 Actor: Harrison Ford, Anne Heche, David Schwimmer

6. VARSITY BLUES
 1999, USA
 Director: Brian Robbins
 Actor: James Van Der Beek, Jon Voight, Paul Walker

www.nicotext.com

1. "-Pain creates character distortion, it's simply not necessary.
 -I'm often in a lot of pain.
 -What kind of pain?
 -I think... psychosexual."

2. "-We could have retired in Hawaii!
 -I have been to Hawaii.
 -Oh yeah? Which island?
 -Come-on-I-wanna-lay-ya."

3. "-Dames are put on this earth to weaken us, drain our energy,
 laugh at us when they see us naked."

4. "-Nothing happened, I'm still the same. All we were doing was
 making out. Besides I just met him and I never go past second
 base with a guy I just met. Witch means nothing below the waist,
 my waist not his."

5. "-I don't know but I've been told.
 -Butz's butt is green with mold.
 -You say thank you I say please.
 -Kevin sits down when he pees."

6. "-Look at him, perverse as a pink pickle."

ANSWER >

1. **DEAD RINGERS**
 1988, CANADA
 Director: David Cronenberg
 Actor: Jeremy Irons, Genevieve Bujold, Heidi Von Palleske

2. **GRUMPIER OLD MEN**
 1995, USA
 Director: Howard Deutch
 Actor: Jack Lemmon, Walter Matthau, Ann Margret

3. **JOHNNY DANGEROUSLY**
 1984, USA
 Director: Amy Heckerling
 Actor: Michael Keaton, Joe Piscopo, Marilu Henner

4. **RIDING IN CARS WITH BOYS**
 2001, USA
 Director: Penny Marshall
 Actor: Drew Barrymore, Steve Zahn, Brittany Murphy

5. **LITTLE GIANTS**
 1994, USA
 Director: Duwayne Dunham
 Actor: Rick Moranis, Ed O'Neill, Shawna Waldron

6. **EVEN COWGIRLS GET THE BLUES**
 1993, USA
 Director: Gus Van Sant
 Actor: Uma Thurman, Lorraine Bracco, Angie Dickinson

1. "-Rule number one: never carry a gun. If you carry a gun you may be tempted to use it. Rule number two: never trust a naked woman."

2. "-You know you were right, Mitch. My life is a "do-over". It's time to get started.
-I hope I can help.
-Now I'm gonna go home, and I'm gonna get Kim pregnant.
-I hope I can help."

3. "-There is a girl out there who might be running for her life from some gigantic turned-on ape."

4. "-One thing you are NOT is a big queen.
-You're right, I'm butch; I can catch a ball, I genuinely like both my parents, and I hate opera. I don't know why I bother being gay."

5. "-You are the greatest lover I've ever had.
-Well, I practice a lot when I'm alone."

6. "-Believe me, I know women - upside down and backwards, which is not a bad way to know 'em, huh?"

ANSWER >

1. ENTRAPMENT
 1999, USA
 Director: Jon Amiel
 Actor: Sean Connery, Catherine Zeta-Jones, Will Patton

2. CITY SLICKERS
 1991, USA
 Director: Ron Underwood,
 Actor: Billy Crystal, Daniel Stern, Bruno Kirby

3. KING KONG
 1976, USA
 Director: John Guillermin
 Actor: Jeff Bridges, Charles Grodin, Jessica Lange

4. LOVE! VALOUR! COMPASSION!
 1997, USA
 Director: Joe Mantello
 Actor: Jason Alexander, Randy Becker, Stephen Bogardus

5. LOVE AND DEATH
 1975, USA
 Director: Woody Allen
 Actor: Woody Allen, Diane Keaton, Harold Gould

6. NEIGHBOURS
 1981, USA
 Director: John G Avildsen
 Actor: John Belushi, Dan Aykroyd, Cathy Moriarty

1. "-All women have a garden, and a garden needs a big hose to water it... Or a small hose... As long as it works."

2. "-Well, the little guy was kinda funny-lookin'.
 -In what way?
 -I dunno, just funny - lookin'.
 -Can ya be any more specific?
 -I couldn't really say. He wasn't circumcised."

3. "-You'll get a new heart and before you know it, you'll be back in your garden, you'll be painting... You'll be getting asked out by fantastic men.
 -I'm getting a new heart, not a new ass."

4. "-Have you seen my car?
 -Yeah.
 -You have?
 -Well, I saw the backseat.
 -No, I'm talking about the whole thing."

5. "-I'd like to take you south of my border, and north of my garter."

6. "-Hey Brad, I hope you have a license to sell hotdogs, because you're fly is open."

ANSWER >

1. **NOW AND THEN**
 1995, USA
 Director: Lesli Linka Glatter
 Actor: Christina Ricci, Thora Birch, Gaby Hoffman

2. **FARGO**
 1996, USA
 Director: Joel Coen
 Actor: Frances McDormand, William H Macy, Steve Buscemi

3. **RETURN TO ME**
 2000, USA
 Director: Bonnie Hunt
 Actor: David Duchovny, Minnie Driver, Carroll O'Connor

4. **DUDE, WHERE'S MY CAR?**
 2000, USA
 Director: Danny Leiner
 Actor: Aston Kutcher, Sean William Scott, Kristy Swanson

5. **LUST IN THE DUST**
 1985, USA
 Director: Paul Bartel
 Actor: Tab Hunter, Divine, Lainie Kazan

6. **TWIN SITTERS**
 1994, USA
 Director: John Paragon
 Actor: Jared Martin, Peter Paul, David Paul

www.nicotext.com

1. "-Let me prepare you for El guapo. Tell me, do you know
 what foreplay is.
 -No.
 -Good neither does El guapo."

2. "-Whenever you touch me, darling, I go as limp as a noodle.
 -Yes I am familiar with that feeling."

3. "-Did you call me?
 -What?
 -I heard dumb bitch. I assumed you were talking to me.
 -I was talking to her.
 -Your name is dumb bitch TOO? No wonder I keep getting
 all of your mail! You know, we could be related. There are a
 lot of us dumb bitches here in LA."

4. "-What would you do if I told you I've been celibate for
 six months?
 -Cross my legs."

5. "-I could never be a woman, 'cause I'd just stay home and play
 with my breasts all day."

6. "-Lulubelle, it's you! I didn't recognize you standing up."

 ANSWER >

1. **THREE AMIGOS**
 1986, USA
 Director: John Landis
 Skådespelare: Steve Martin, Chevy Chase, Martin Short

2. **LOLITA**
 1962, UNITED KINGDOM
 Director: Stanley Kubrick
 Actor: James Mason, Shelley Winters, Peter Sellers

3. **THE TRUTH ABOUT CATS & DOGS**
 1996, USA
 Director: Michael Lehmann
 Actor: Uma Thurman, Janeane Garofalo, Ben Chaplin

4. **SKIN DEEP**
 1989, USA
 Director: Blake Edwards
 Actor: John Ritter, Vincent Gardenia, Alyson Reed

5. **LA. STORY**
 1991, USA
 Director: Mick Jackson
 Actor:Steve Martin, Victoria Tennant, Richard E Grant

6. **GO WEST**
 1940, USA
 Director: Edward Buzzell
 Actor: John Carroll, Diana Lewis, Walter Woolf King

www.nicotext.com

1. "-So I've sown a few wild oats.
 -A few? You could qualify for a farm loan."

2. "-Speaking of Doberman, can I please have another roommate?
 -What 's the matter with Doberman?
 -He wet the bed!
 -Oh well, every once and awhile...
 -No, he did it from across the room."

3. "-Look, mistletoe. Many a maiden lost her virtue thanks to
 this little plant.
 -In my country we talk to our women we do not drug them
 with plants."

4. "-I don't want to use profanity, but for the first time in my life
 I had the caca scared out of me!"

5. "-Excuse me, el doctor! Hello...?
 Don't sew anything up thats supposed to remain open, ok?"

6. "-I race cars, play tennis, and fondle women, BUT!
 I have weekends off, and I am my own boss."

ANSWER >

1. **PILLOW TALK**
 1959, USA
 Director: Michael Gordon
 Actor: Doris Day, Rock Hudson, Tony Randall

2. **SGT. BILKO**
 1996, USA
 Director: Jonathan Lynn
 Actor: Steve Martin, Dan Aykroyd, Phil Hartman

3. **ROBIN HOOD: PRINCE OF THIEVES**
 1991, USA
 Director: Kevin Reynolds
 Actor: Kevin Costner, Morgan Freeman, Mary Elisabeth

4. **MURDER BY DEATH**
 1976, USA
 Director: Robert Moore
 Actor: Peter Sellers, Peter Falk, David Niven

5. **CITY SLICKERS**
 1991, USA
 Director: Ron Underwood,
 Actor: Billy Crystal, Daniel Stern, Bruno Kirby

6. **ARTHUR**
 1981, USA
 Director: Steve Gordon
 Actor: Dudley Moore, Liza Minelli, John Gielgud

1. "-So... Can I see it?
 -I don't think you get the gravity of this situation here.
 -Sorry... Can I see it? Come on, it's not every day that
 your best friend grows a penis."

2. "-Do you mind if I take a look at your armpits?
 I think armpits are the prettiest part of a woman's body."

3. "-Have you ever made love to a woman until she lost
 consciousness?
 -Twice. No, four... four times."

4. "-When was the last time you were with a woman?
 -Saturday will make a year.
 -Ow!
 -Gee, if I had known, I'd have gotten you a cake."

5. "-About this pile-of-shit pimp in here. In this country, we try
 to protect the rights of individuals. It's called the Miranda Act,
 and it says that you can't even touch his ass.
 -I do not want to touch his ass. I want to make him talk!"

6. "-I want more than just sex.
 -That's why God invented television."

ANSWER >

1. **THE HOT CHICK**
 2002, USA
 Director: Tom Brady
 Actor: Rebecca Lin, Rob Schneider, Rachel McAdams

2. **FLIRTING WITH DISASTER**
 1996, USA
 Director: David O. Russell
 Actor: Ben Stiller, Patricia Arquette, Téa Leoni

3. **FEDS**
 1988, USA
 Director: Daniel Goldberg
 Actor: Rebecca De Mornay, Mary Gross, Ken Marshall

4. **CITY SLICKERS II: THE LEGEND OF CURLY'S GOLD**
 1994, USA
 Director: Paul Weiland
 Actor: Billy Crystal, Daniel Stern, Jon Lovitz

5. **RED HEAT**
 1988, USA
 Director: Walter Hill
 Actor: Arnold Schwarzenegger, James Belushi, Peter Boyle

6. **LOVE & HUMAN REMAINS**
 1993, CANADA
 Director: Denys Arcand
 Actor: Thomas Gibson, Ruth Marshall, Cameron Bancroft

1. "-You think those whales piss in that water?
 -No, I think they use the men's room next to the Burger King."

2. "-Why would anybody want to steal a groundhog?
 -I can think of a couple of reasons... The pervert!"

3. "-Cookie?
 -No thank you, sir.
 -Young lady?
 -No thank you, sir.
 -No, I was just offering him a young lady."

4. "-Hey, Fletcher, how's it hanging?
 -Short, shriveled, and always to the left."

5. "-Cher, you're a virgin?
 -You say that like it's a bad thing.
 -Besides, the PC term is 'Hymenally Challenged."

6. "- I'm not my father, Diane, just like you're not your father.
 - If we were our fathers, what we did last night would only
 be legal in Arkansas."

ANSWER >

1. **ANALYZE THIS**
 1993, USA

 1999, USA
 Director: Harold Ramis
 Actor: Robert De Niro, Billy Crystal, Lisa Kudrow

2. **GROUNDHOG DAY**
 1993, USA
 Director: Harold Ramis
 Actor: Bill Murray, Andie MacDowell, Chris Elliott

3. **HOT SHOTS! PART DEUX**
 1993, USA
 Director: Jim Abrahams
 Actor: Charlie Sheen, Lloyd Bridges, Valeria Golino

4. **LIAR LIAR**
 1997, USA
 Director: Tom Shadyac
 Actor: Jim Carrey, Maura Tierney, Jennifer Tilly

5. **CLUELESS**
 1995, USA
 Director: Amy Heckerling
 Actor: Alicia Silverstone, Stacey Dash, Brittany Murphy

6. **JANE AUSTEN'S MAFIA!**
 1998, USA
 Director: Jim Abrahams
 Actor: Jay Mohr, Billy Burke, Christina Applegate

1. "-You can open the safe with your balls or without 'em.
 -First choice."

2. "-This horse was not this lively this morning,
 I order this horse drug tested.
 -Quick someone get a urine bottle and a mop."

3. "-The only way you'll ever end up to lying next to me Max,
 is if were run down by the same car."

4. "-Would you look at those tits?
 -I think they're gross.
 -That's because you don't have any."

5. "-Could you leave? Please?
 -I haven't finished charming you yet.
 -You haven't started.
 -Gimme a chance.
 -Look, go find yourself a nice little cowgirl and
 make nice little cowbabies and leave me alone.
 -I'm hung like a horse. Think about it."

6. "-I'm a widower. That's like catnip to a cat, in a town where
 the ladies outnumber you ten to one."

ANSWER >

1. JOSHUA TREE
 1993, USA
 Director: Vic Armstrong
 Actor: Dolph Lundgren, George Segal, Kristian Alfonso

2. SGT. BILKO
 1996, USA
 Director: Jonathan Lynn
 Actor: Steve Martin, Dan Aykroyd, Phil Hartman

3. RAW DEAL
 1986, USA
 Director: John Irwin
 Actor: Arnold Schwarzenegger, Kathryn Harrold,
 Darren McGavin

4. THE LEGEND OF BILLIE JEAN
 1985, USA
 Director: Matthew Robbins
 Actor: Helen Slater, Keith Gordon, Christian Slater

5. THE LAST SEDUCTION
 1994, USA
 Director: John Dahl
 Actor: Linda Fiorentino, Peter Berg, JT Walsh

6. MURPHY'S ROMANCE
 1985, USA
 Director: Martin Ritt
 Actor: Sally Field, James Garner, Brian Kerwin

1. "-I'm the greatest, I'm number one!
 -To me, you look like number two, know what I mean?
 -What DOES he mean, Miss Skeffington?
 -I'll tell you later. It's disgusting."

2. "-I'd known her for years. We used to go to all the police functions together. Ah, how I loved her, but she had her music. I think she had her music. She'd hang out with the Chicago Male Chorus and Symphony. I don't recall her playing an instrument or be able to carry a tune. Yet she was on the road 300 days of the year. In fact I bought her a harp for christmas. She asked me what it was."

3. "-And do you know what we do with shit around here, Nick?
 -From your breath, I'd say you eat it."

4. "-This place has a sign hangin' over the urinal that says,
 "Don't eat the big white mint."."

5. "-What would I have to give you for one little kiss?
 -Chloroform."

6. "-What happened?
 -He poured hot coffee all over my penis.
 Took my clothes and he ran away."

ANSWER >

1. MURDER BY DEATH
 1976, USA
 Director: Robert Moore
 Actor: Peter Sellers, Peter Falk, David Niven

2. THE NAKED GUN:
 FROM THE FILES OF POLICE SQUAD!
 1988, USA
 Director: David Zucker
 Actor: Leslie Nielsen, George Kennedy, Priscilla Presley

3. PLAIN CLOTHES
 1988, USA
 Director: Martha Goolidge
 Actor: Arliss Howard, Suzy Amis, George Wendt

4. ROAD HOUSE
 1989, USA
 Director: Rowdy Herrington
 Actor: Patrick Swayze, Kelly Lynch, Sam Elliott

5. FOR THE BOYS
 1991, USA
 Director: Mark Rydell
 Actor: Bette Midler, James Caan, George Segal

6. FATHERS' DAY
 1997, USA
 Director: Ivan Reitman
 Actor: Robin Williams, Billy Crystal, Julia Louis Dreyfus

1. "-The last time I was this naked in public I was coming out of a uterus!"

2. "-Hey Tiny, who's playing today?
 -Jolly Green Giants and the Shitty Beatles.
 -Shitty Beatles? Are they any good?
 -They suck!
 -Then it's not just a clever name."

3. "-Well I like school...and I like football...and I'm gonna keep doin' 'em both because they make me feel good!
 -And by the way, Mama... Alligators are ornery because of their medulla oblongata!
 -And I like Vicki and she likes me back! And she showed me her boobies and I like them too!"

4. "-Venkman, get a stool sample.
 -Business, or personal?"

5. "-Can I talk to my wife?
 -I think she is in the shower Howard, do you want me to check?
 -NO!"

6. "-Are you messing with that Mari Hoff?
 -Hoff and on.
 -More on then Hoff, I should say."

ANSWER >

1. MISS CONGENIALITY
 2000, USA
 Director: Donald Petrie
 Actor: Sandra Bullock, Michael Caine, Benjamin Bratt

2. WAYNE'S WORLD
 1992, USA
 Director: Penelope Spheeris
 Actor: Mike Myers, Dana Carvey, Rob Lowe

3. THE WATERBOY
 1998, USA
 Director: Frank Coraci
 Actor: Adam Sandler, Kathy Bates, Fairuza Balk

4. GHOSTBUSTERS II
 1989, USA
 Director: Ivan Reitman
 Actor: Bill Murray, Dan Aykroyd, Harold Ramis

5. JINGLE ALL THE WAY
 1996, USA
 Director: Brian Levant
 Actor: Arnold Scwarzenegger, Sinbad, Phil Hartman

6. LITTLE VOICE
 1998, UNITED KINGDOM
 Director: Mark Herman
 Actor: Brenda Blethyn, Jane Horrocks, Michael Caine

www.nicotext.com

1. "-Do you want to go home with me?
 -No.
 -I had to ask, because to be honest with you, I don't find you the least bit attractive. Now do you want to go home with me?
 -No."

2. "-...And then Mommy kissed Daddy, and the angel told the stork, and the stork flew down from heaven, and put the diamond in the cabbage patch, and the diamond turned into a baby!
 -Our parents are having a baby too.
 -They had sex."

3. "-When I'm good, I'm very, very good, but when I'm bad, I'm better."

4. "-Alright, Lightman. Maybe you can tell us who first suggested the idea of reproduction without sex.
 -Um, your wife?"

5. "-What is it, fear or anxiety?
 -Homosexual panic."

6. "-Hillary. That's an unusual name.
 -It's a German name. It means 'she whose bosoms defy gravity.'"

ANSWER >

1. **BEAUTIFUL GIRLS**
 1996, USA
 Director: Ted Demme
 Actor: Matt Dillon, Noah Emmerich, Annabeth Gish

2. **ADDAMS FAMILY VALUES**
 1993, USA
 Director: Barry Sonnenfeld
 Actor: Anjelica Huston, Raul Julia, Christopher Lloyd

3. **I'M NO ANGEL**
 1933, USA
 Director: Wesley Ruggles
 Actor: Mae West, Cary Grant, Edward Arnold

4. **WARGAMES**
 1983, USA
 Director: John Badham
 Actor: Matthew Broderick, Dabney Coleman, John Wood

5. **PLAY IT AGAIN SAM**
 1972, USA
 Director: Herbert Ross
 Actor: Woody Allen, Diane Keaton, Tony Roberts

6. **TOP SECRET!**
 1984, USA
 Director: Jim Abrahams, David Zucker, Jerry Zucker
 Actor: Val kilmer, Lucy Gutteridge, Christopher Villiers

1. "-Mary Pat Montgomery's the one who told me about boners.
 It isn't a bone at all, it's a muscle, this cousin of her dated
 a Clemson Tiger who sprained his in a game, and she had
 to massage it every night when it got hard because he was
 in so much pain."

2. "-Richard, were you watching Spank-travision?
 -Okay let's get some shut eye!
 -Maybe you were watching a movie with that funny comedian,
 oh what's his name? Buddy Whackett?"

3. "-The urine stain on your pants signifies that you are a
 single-shake man, far too busy for the follow-up jiggle."

4. "-Such an unusual name, "Latrine."
 How did your family come by it?
 -We changed it in the 9th century.
 -You mean you changed it TO "Latrine"?
 -Yeah. Used to be "Shithouse."
 -It's a good change. That's a good change!"

5. "-I think it's the pate. Stuff probably looks better on the way out!"

6. "-I can voluntarily perform a fanny fart at all times."

ANSWER >

1. SHAG
 1988, USA
 Director: Zelda Barron
 Actor: Phoebe Cates, Scott Coffey, Bridget Fonda

2. TOMMY BOY
 1995, USA
 Director: Peter Segal
 Actor: Chris Farley, David Spade, Brian Dennehy

3. ACE VENTURA: WHEN NATURE CALLS
 1995, USA
 Director: Steve Oedekerk
 Actor: Jim Carrey, Ian Mcneice, Simon Callow

4. ROBIN HOOD: MEN IN TIGHTS
 1993, USA
 Director: Mel Brooks
 Actor: Cary Elwes, Richard Lewis, Roger Rees

5. ACE VENTURA: PET DETECTIVE
 1994, USA
 Director: Tom Shadyae
 Actor: Jim Carrey, Courteney Cox, Sean Young

6. HUMAN TRAFFIC
 1999, UNITED KINGDOM
 Director: Justin Kerrigan
 Actor: John Simm, Lorraine Pilkington, Shaun Parkes

www.nicotext.com

1. "-Where do I start? It's not you. Well actually it is you. Look, I'm just not... I'm not attracted to you anymore. I need space. You kinda... you kinda gross me out. In the beginning it was different. In the beginning you were better. But then I got to know you real well, and I came to realize that you're a fat idiot."

2. "-Your dog sure has a surprised look on his face.
 -That's because you're looking at his butt.
 -Oh then he certainly won't appreciate that treat I just feed him."

3. "-It's like your Aunt Edna's ass. It goes on forever and it's just as frightening."

4. "-Due to a mix up in urology,
 there will be no apple juice served today."

5. "-A martini's like a woman's breast; one ain't enough and three is too manny."

6. "-Hey, ya' got Pac Man?
 -No.
 -Ya' got Space Invaders?
 -Nope.
 -Ya' got Asteroids?
 -Naw, but my dad does. Can't even sit on the toilet some days."

ANSWER >

1. NOTHING TO LOSE
 1997, USA
 Director: Steve Oedekerk
 Actor: Martin Lawrence, Tim Robbins, John C McGinley

2. WRONGFULLY ACCUSED
 1998, USA/GERMANY
 Director: Pat Proft
 Actor: Leslie Nielsen, Richard Crenna, Kelly LeBrock

3. PARENTHOOD
 1989, USA
 Director: Ron Howard
 Actor: Steve Martin, Mary Steenburgen, Dianne Wiest

4. YOUNG DOKTORS IN LOVE
 1982, USA
 Director: Garry Marshall
 Actor: Michael McKean, Sean Young, Harry Dean Stanton

5. THE PARALLAX VIEW
 1974, USA
 Director: Alan J Pakula
 Actor: Warren Beatty, Paula Prentiss, William Daniels

6. VACATION
 1983, USA
 Director: Harold Ramis
 Actor: Chevy Chase, Beverly D'Angelo,
 Anthony Michael Hall

www.nicotext.com

1. "-Tee-Hee, on Solitaire's first wrong answer, you will snip the little finger of Mr. Bond's left hand. On the next wrong answer, you will move on to more... "vital" parts of his anatomy."

2. "-But even a skinny squirrel would make a nice fur jock-strap.
-Well that makes sense...
-Since squirrels hide nuts! Thank you! I'll be here all week!"

3. "-Can I help you Dr...?
-Oh it's me, Dr. Rosenpenis. I'm just here to check out 4 Alan Stanwyk's file."

4. "-Hey, what are you reading, Mister Beddoes?
-I am reading "Love's Captive," by Mrs. Arabella Richardson.
-Is it about sex?
-No, it's about 10:30, Mister Foscarelli."

5. "-Where's your husband?
-In Houston, on business.
-Well, how nice for you.
-Maybe you too."

6. "-The last time I was in water like this I had to stay up all night picking leeches off of my scrotum."

ANSWER >

1. LIVE AND LET DIE
 1973, UNITED KINGDOM
 Director: Guy Hamilton
 Actor: Roger Moore, Yaphet Kotto, Jane Seymour

2. MEET THE DEEDLES
 1998, USA
 Director: Steve Boyum
 Actor: Paul Walker, Steve Van, Wormer, John Ashton

3. FLETCH
 1985, USA
 Director: Michael Ritchie
 Actor: Chevy Chase, Dana Wheeler-Nicholson, Tim Matheson

4. MURDER ON THE ORIENT EXPRESS
 1974, UNITED KINGDOM
 Director: Sidney Lumet
 Actor: Albert Finney, Lauren Bacall, Martin Balsam

5. HEAVEN'S PRISONERS
 1996, USA
 Director: Phil Joanou
 Actor: Alec Baldwin, Mary Stuart Masterson, Kelly Lynch

6. ANACONDA
 1997, USA
 Director: Luis Llosa
 Actor: Jennifer Lopez, Ice Cube, Jon Voight

1. "-It has no name. Many brave men died to bring it here from the Galaxy of Pleasure....It will make your nights with Ming more...agreeable.
 -Will it make me forget?
 -No, but it will make you not mind remembering."

2. "-This is America, and we're Christians here -- aside from a few Jewish people who were just born that way -- and I can tell you one thing: Jesus Christ and his apostles were certainly not into "man-on-man action," which is how they describe it on their porno videos, which, I am proud to say, Blockbuster does not carry. Um, I work there and it's very family...
 -Plus, that religion John Travolta belongs to."

3. "-He tried to kill me with his penis!"

4. "-Joe, put your shirt back on or Grace may never be satisfied by another man!"

5. "-Remember, at 4:00 you have to shove a pineapple up Hitler's ass."

6. "-I feel like a gerbil smothering in Richard Gere's butthole."

ANSWER >

1. **FLASH GORDON**
 1980, USA
 Director: Mike Hodges
 Actor: Sam J Jones, Melody Anderson, Max von Sydow

2. **THE OPPOSITE OF SEX**
 1998, USA
 Director: Don Roos
 Actor: Christina Ricci, Martin Donovan, Lisa Kudrow

3. **LIPSTICK**
 1976, USA
 Director: Lamont Johnson
 Actor: Margaux Hemingway, Chris Sarandon, Perry King

4. **RETURN TO ME**
 2000, USA
 Director: Bonnie Hunt
 Actor: David Duchovny, Minnie Driver, Carroll O'Connor

5. **LITTLE NICKY**
 2000, USA
 Director: Steven Brill
 Actor: Adam Sandler, Patricia Arquette, Harvey Keitel

6. **THE DOOM GENERATION**
 1995, USA/FRANCE
 Director: Gregg Araki
 Actor: James Duval, Rose McGowan, Johnathon Schaech

1. "-To be with another woman, that is French. To be caught, that is American."

2. "-I'm allowing the good folks of Dallas to have some verbal intercourse with the rest of the USA."

3. "-Did you bump uglies with my sister?"

4. "-What's wrong with you?
 -I don't know what to do.
 -I brought a book.
 -A book?
 -El Joy De Sexo.
 -It's in Spanish.
 -I'm gonna translate. It has a very happy ending.
 You're gonna love it."

5. "-I love you from the top of my head to the tip of my penis."

6. "-Gosh, I didn't realize it was going to be this formal.
 If I had known it was going to be this kind of party
 I would have worn underwear."

ANSWER >

1. **DIRTY ROTTEN SCOUNDRELS**
 1988, USA
 Director: Frank Oz
 Actor: Steve Martin, Michael Caine, Glenne Headly

2. **TALK RADIO**
 1988, USA
 Director: Oliver Stone
 Actor: Eric Bogosian, Alec Baldwin, Ellen Greene

3. **TANGO & CASH**
 1989, USA
 Director: Andrei Konchalovsky
 Actor: Sylvester Stallone, Kurt Russell, Teri Hatcher

4. **EASY MONEY**
 1983, USA
 Director: James Signorelli
 Actor: Rodney Dangerfield, Joe Pesci, Geraldine Fitzgerald

5. **THE RULING CLASS**
 1972, UNITED KINGDOM
 Director: Peter Medak
 Actor: Peter O´ Toole, Alastair Sim, Arthur Lowe

6. **ARMED AND DANGEROUS**
 1986, USA
 Director: Mark J Lester
 Actor: John Candy, Eugene Levy, Robert Loggia

RATED: R

www.nicotext.com

1. "-I'd be the worst possible Godfather. I'd probably drop her on her head at her christening. I'd forget all her birthdays until she was 18. Then I'd take her out and get her drunk. And, let's face it, quite possibly try and sleep with her."

2. "-You've never had an orgasm? Not even manually?
-I've never tried it.
-You've never double-clicked your mouse?"

3. "-Shall we shag now, or shall we shag later? How do you like to do it? Do you like to wash up first? You know, top and tails...whores bath? Personally before I'm on the job, I like to give my undercarriage a bit of a how's your father!"

4. "-Eliot, do I look like a beautiful blonde with big tits and an ass that tastes like French vanilla ice cream?
-What?"

5. "-Who was your date THIS week? Lubridina? Vasolina?"

6. "-What do you know about Prozac?
-Makes you happy, but there's side effects.
-Like what?
-Limp noodle."

ANSWER >

1. **ABOUT A BOY**
 UNITED KINGDOM
 Director: Chris Weitz, Paul Weitz
 Actor: Hugh Grant, Toni Collette, Nicholas Hoult

2. **AMERICAN PIE**
 1999, USA
 Director: Paul Weitz
 Actor: Jason Biggs, Shannon Elizabeth, Alyson Hannigan

3. **AUSTIN POWERS: INTERNATIONAL MAN OF MYSTERY**
 1997,USA
 Director: Jay Roach
 Actor: Mike Myers, Elizabeth Hurley, Michael York

4. **TRUE ROMANCE**
 1993, USA
 Director: Tony Scott
 Actor: Christian Slater, Patricia Arquette, Dennis Hopper

5. **WHIPPED**
 2000, USA
 Director: Peter M. Cohen
 Actor: Amanda Peet, Brian Van Holt, Judah Domke

6. **STRIPTEASE**
 1996, USA
 Director: Andrew Bergman
 Actor: Demi Moore, Armand Assante, Burt Reynolds

1. "-There is no real loyalty, and the first person who taught me that was you.
 -I figure I was trying to sleep with you at the time.
 -Well, it worked."

2. "-I'm leaving the country, Mitch. I need a fake passport and I need money, lots of it.
 -Well why didn't you say so? Hold on a minute while I pull that outta my ass."

3. "-Why, you wouldn't even look at a clock unless hours were lines of coke, dials looked like the signs of gay bars, or time itself was a fair hustler in black leather."

4. "-What's "forget about it"?
 -"Forget about it" is like if you agree with someone, you know, like "Raquel Welsh is one great piece of ass, forget about it.".."

5. "-Oh, how can I put this delicately? It's just that I'm not really in the vagina business."

6. "-You were hoping for a goodnight kiss.
 -No, you know. I'll tell ya, I was hoping for a goodnight lay, but I'll settle for like a kiss."

ANSWER >

1. **JERRY MAGUIRE**
 1996, USA
 Director: Cameron Crowe
 Actor: Tom Cruise, Cuba Gooding Jr., Reneé Zellweger

2. **THE LONG KISS GOODNIGHT**
 1996, USA
 Director: Renny Harlin
 Actor: Geena Davis, Samuel L Jackson, Craig Bierko

3. **MY OWN PRIVATE IDAHO**
 1991, USA
 Director: Gus Van Sant
 Actor: River Phoenix, Keanu Reeves, James Russo

4. **DONNIE BRASCO**
 1997, USA
 Director: Mike Newell
 Actor: Al Pacino, Johnny Depp, Michael Madsen

5. **PETER'S FRIENDS**
 1992, UNITED KINGDOM
 Director: Kenneth Branagh
 Actor: Kenneth Branagh, Emma Thompson, Rita Rudner

6. **GOOD WILL HUNTING**
 1997, USA
 Director: Gus Van Sant
 Actor: Matt Damon, Robin Williams, Ben Affleck

www.nicotext.com

1. "-I got red, I got green, I got yellow... I'm out of purple,
 but I do have one Gold Circle coin left...
 the condom of champions... the one and only... nothin' is gettin'
 through this sucker. Whaddya say, hmm?"

2. "-You're gay?
 -No, I got both my nipples pierced and bought a house
 in Morocco because I'm John fucking Wayne!"

3. "-Well shoot, I don't want to go to jail, there are lesbians there.
 -I always thought that was one of the advantages."

4. "-I know I seem a little bit on the kinky side, but deep
 down I'm a sensitive and vulnerable girl. Don't let my
 dildoes, vibrators and handcuffs fool you."

5. "-You actually put your dick in this woman?
 -Well, yeah, sometimes."

6. "-A condom is the glass slipper for our generation.
 You slip one on when you meet a stranger. You "dance"
 all night, and then you throw it away. The condom, I mean,
 not the stranger."

ANSWER >

1. PRETTY WOMAN
 1990, USA
 Director: Garry Marshall
 Actor: Richard Gere, Julia Roberts, Ralph Bellamy

2. ROCK STAR
 2001, USA
 Director: Stephen Herek
 Actor: Mark Wahlberg, Jennifer Aniston, Jason Flemyng

3. HIDEOUS
 1997, USA
 Director: Charles Band
 Actor: Michael Citriniti, Rhonda Griffin, Mel Johnson Jr.

4. HOLD ME, THRILL ME, KISS ME
 1993, USA
 Director: Joel Hershman
 Actor: Max Parrish, Adrienne Shelly, Sean Young

5. THE DOORS
 1991, USA
 Director: Oliver Stone
 Actor: Val Kilmer, Frank Whaley, Meg Ryan

6. FIGHT CLUB
 1999, USA
 Director: David Fincher
 Actor: Brad Pitt, Edward Norton, Helena Bonham Carter

1. "-You have lovely hands. Do you moisturize?
-I'm Sorry?
-You know, I've tried all sorts of moisturizers. I even went fragrance free for a whole year. Now my sister, she uses some kind of uh... uh... uh.. uh...aloe vera with a little sunscreen in it, and ideally, we should all wear gloves when going to bed, but I found out that that creates a kind of an interference with my... social agenda, you know what I mean."

2. "-Ah, the missus, Chief! If they don't like you going out, they'll love you comin' in!"

3. "-Who do you have to screw to get a vodka?
-Me.
-Make it a ginger ale."

4. "-It's kind of a compulsion with him, he has to exchange fluids with everyone he meets, that why he never have pets."

5. "-I'm going steady, and I French kiss.
-So? Everybody does that.
-Yeah, but Daddy says I'm the best at it."

6. "-If bullshit were music, you'd be a big brass band."

ANSWER >

1. **OCEAN'S ELEVEN**
 2001, USA
 Director: Steven Sonderbergh
 Actor: George Clooney, Matt Damon, Andy Garcia

2. **JAWS**
 1975, USA
 Director: Steven Spielberg
 Actor: Roy Schneider, Robert Shaw, Richard Dreyfuss

3. **MR. SATURDAY NIGHT**
 1992, USA
 Director: Billy Crystal
 Actor: Billy Crystal, David Paymer, Julie Warner

4. **SHOOTING FISH**
 1997, USA
 Director: Stefan Schwatz
 Actor: Dan Futterman, Stuart Townsend, Kate Beckinsale

5. **VACATION**
 1983, USA
 Director: Harold Ramis
 Actor: Chevy Chase, Beverly D'Angelo, Anthony Michael Hall

6. **THE DOOM GENERATION**
 1995, USA/FRANCE
 Director: Gregg Araki
 Actor: James Duval, Rose McGowan, Johnathon Schaech

1. "-Haven't you ever had an orgasm?
-Oh, yeah, sure - No, not really. I mean,
not with someone else in the room."

2. "-Pardon my French, but Cameron is so tight that if you
stuck a lump of coal up his ass, in two weeks you would
have a diamond."

3. "-He said that faith is like a glass of water. When you're young,
the glass is small, and it's easy to fill up. But the older you get,
the bigger the glass gets, and the same amount of liquid doesn't
fill it anymore. Periodically, the glass has to be refilled.
-You're suggesting I need to get filled?
-In more ways than one."

4. "-He sells reproductions! His furniture's as fake as my orgasms!"

5. "-Do you ever wet the bed?
-No, I generally just piss over the side."

6. "-Missing? Please! It's the weekend. He's most likely holed up
in some hotel somewhere with a girl, or boy...farm animal...
whatever!"

ANSWER >

1. **CASUAL SEX**
 1988, USA
 Director: Genevieve Robert
 Actor: Lea Thompson, Victoria Jackson, Stephen Shellen

2. **FERRIS BUELLER'S DAY OFF**
 1986, USA
 Director: John Hughes
 Actor: Matthew Broderick, Alan Ruck, Mia Sara

3. **DOGMA**
 1999, USA
 Director: Kevin Smith
 Actor: Matt Damon, Ben Affleck, Linda Fiorentino

4. **DROP DEAD GORGEOUS**
 1999, USA
 Director: Michael Patrick Jann
 Actor: Kirsten Dunst, Denise Richard, Kirstie Alley

5. **UP THE ACADEMY**
 1980, USA
 Director: Robert Downey Sr.
 Actor: Wendell Brown, Tommy Citera, J. Hutchison

6. **URBAN LEGEND**
 1998, USA
 Director: Jamie Blank
 Actor: Jared Leto, Alicia Witt, Rebecca Gayheart

1. "-Look at us go! We're zooming!
 -I told you! We're hauling ass!
 -We're hauling ass! Alrighty!
 -Guess what I got back there.
 -You just told me. Ass! We're hauling ass!"

2. "-You weren't even multiorgasmic before you met me, were you?
 -You really expect me to keep on reassuring you sexually even
 now when we disgust each other?"

3. "-They was giving me ten thousand watts a day, you know,
 and I'm hot to trot! The next woman takes me on's gonna light
 up like a pinball machine and pay off in silver dollars!"

4. "-How come Isabel screams during sex?
 -How do you know she screams during sex?
 -I live in the same country."

5. "-And another thing, your beer tastes like piss.
 -We know. We piss in it."

6. "-You left Bria with the Asshole?
 -His name is Steve.
 -Oh, I forgot, the asshole part is silent!"

ANSWER >

1. **RAT RACE**
 2001, USA
 Director: Jerry Zucker
 Actor: Whoopi Goldberg, Jon Lovitz, Rowan Atkinson

2. **THE WAR OF THE ROSES**
 1989, USA
 Director: Danny DeVito
 Actor: Michael Douglas, Kathleen Turner, Danny DeVito

3. **ONE FLEW OVER THE CUCKOO'S NEST**
 1975, USA
 Director: Milos Forman
 Actor: Jack Nicholson, Louise Fletcher, Brad Dourif

4. **STEPMOM**
 1998, USA
 Director: Chris Columbus
 Skådespelare: Susan Sarandon, Julia Roberts, Ed Harris

5. **DESPERADO**
 1995, USA
 Director: Robert Rodriguez
 Actor: Antonio Banderas, Joaquim de Almeida, Salma Hayek

6. **DRIVE**
 1997, USA
 Director: Steve Wang
 Actor: Mark Dacascos, Kadeem Hardison,
 John Pyper-Ferguson

1. "-I'll get the lubricant...
 -No time for lubricant!
 -There's ALWAYS time for lubricant!"

2. "-Sometimes I got so bored of trying to touch her breast
 that I would try to touch her between her legs. It was like
 trying to borrow a dollar, getting turned down, and asking
 for 50 grand instead."

3. "-Nice costume.
 -You too. Except that when I dress up as a frigid bitch,
 I try to look a little less constipated."

4. "-It is dangerous! You know, there's nothing more off-putting
 in a wedding than a priest with an enormous erection, yech!"

5. "-That girl, Drew Decker, got killed last night.
 -Hey, I think I knew her. She had a brother, Steve.
 Long hair, pretty little blonde, perfect ass.
 -That was her!
 -No, I was talking about her brother, Steve."

6. "-I used to make obscene phone calls to her, collect,
 and she used to accept the charges all the time."

 ANSWER >

1. **EVOLUTION**
 2001, USA
 Director: Ivan Reitman
 Actor: David Duchovny, Orlando Jones,
 Seann William Scott

2. **HIGH FIDELITY**
 2000, USA
 Director: Stephen Frears
 Actor: John Cusack, Iben Hjejle, Todd Louise

3. **LEGALLY BLONDE**
 2001, USA
 Director: Robert Luketic
 Actor: Reese Witherspoon, Luke Wilson, Selma Blair

4. **FOUR WEDDINGS AND A FUNERAL**
 1994, UNITED KINGDOM
 Director: Mike Newell
 Actor: Hugh Grant, Andie MacDowell, Kristin Scott

5. **SCARY MOVIE**
 2000, USA
 Director: Keenen Ivory Wayans
 Actor: John Abrahams, Carmen Electra, Shannon Elizabeth

6. **TAKE THE MONEY AND RUN**
 1969, USA
 Director: Woody Allen
 Actor: Woody Allen, Janet Margolin, Marcel Hillaire

www.nicotext.com

1. "-You gotta have presence on the court. Presence like a cheetah rather than a chimp. Sure, they both got it, but Chimpy gotta jump his nuts around to get it. The shy cheetah moves with total nonchalance, stickin' it to them in his sexy, slow strut. Me? I play like a cheetah."

2. "-I'm Cammie, the Russian tease.
 -Violet, the Jersey nun.
 -We all play our little parts. That one's Rachel, the New York bitch. Only Rachel really is a bitch, and I really am a tease.
 -Cammie, you can only be a tease if you stop sleepin' around, babe. -Yeah, I keep forgetting that part!"

3. "-Sparky sperm is loose, and he's headed for the target, Edna the egg, and when he reaches it, he makes a baby!"

4. "-Ugly pink little things. To think that sex could lead to something so disastrous."

5. "-Your father would never do anything like that.
 -Ohhh. Hmm. Well, you know Mom, there are ways to enjoy yourself without Dad."

6. "-Squeeze the trigger, don't yank it, it's not your dick."

ANSWER >

1. **THE BASKETBALL DIARIES**
 1995, USA
 Director: Scott Kalvert
 Actor: Leonardo Di Caprio, Lorraine Bracco, Bruno Kirby

2. **COYOTE UGLY**
 2000, USA
 Director: David McNally
 Actor: Piper Perabo, Adam Garcia, Maria Bello

3. **TEEN WITCH**
 1989, USA
 Director: Dorian Walker
 Actor: Zelda Rubinstein, Shelley Berman, Dan Gauthier

4. **LUCINDA'S SPELL**
 1998, USA
 Director: Jon Jacobs
 Actor: Jon Jacobs II, Kristina Fulton, Shana Betz

5. **PLEASANTVILLE**
 1998, USA
 Director: Gary Ross
 Actor: Tobey Maguire, Jeff Daniels, Joan Allen

6. **HARLEY DAVIDSON AND THE MARLBORO MAN**
 1991, USA
 Director: Simon Wincher
 Actor: Mickey Rourke, Don Johnson, Chelsea Field

www.nicotext.com

1. "-How tall are you, private?
 -Sir, five-foot-nine, sir!
 -Five-foot-nine, I didn't know they stacked shit that high."

2. "-Didn't you say that what you liked about our relationship
 is that we didn't have to think. We could just be there for
 each other.
 -A suicidal paranoiac would say anything to get laid."

3. "-I don't eat shit. It's against my religion.
 -What religion is that?
 -The religion of sanity, Peter. You should try it some time."

4. "-Like my Daddy always said, "If you can't get out of it, get into it."
 -I thought your daddy used to say, "If you can't fix it, fuck it."
 -He said that, too."

5. "-Screw the dolphins.
 -A guy actually tried that last year,
 he was banned from Sea world for life."

6. "-Just because she's a female gynecologist, that doesn't
 mean she's a lesbian. And even if she was, at least my
 mom didn't give birth to me while she was on LSD."

ANSWER >

1. **FULL METAL JACKET**
 1987, UNITED KINGDOM
 Director: Stanley Kubrick
 Actor: Matthew Modine, Adam Baldwin, Vincent D'Onofrio

2. **THE FISHER KING**
 1991, USA
 Director: Terry Gilliam
 Actor: Robin Williams, Jeff Bridges, Amanda Plummer

3. **BLUE IN THE FACE**
 1995, USA
 Director: Wayne Wang, Paul Auster
 Actor: Harvey Keitel, Lou Reed, Michael J Fox

4. **FLASHPOINT**
 1984, USA
 Director: William Tannen
 Actor: Kris Kristofferson, Treat Williams, Rip Torn

5. **SHE'S ALL THAT**
 1999, USA
 Director: Robert Iscove
 Actor: Freddie Prinze Jr., Rachel Leigh Cook, Matthew Lillard

6. **DETROIT ROCK CITY**
 1999, USA
 Director: Adam Rifkin
 Actor: Edward Furlong, Guiseppe Andrews, James De Bello

www.nicotext.com

1. "-I like to dress in women's clothing.
 -You're a fruit?
 -No, not at all. I love women. Wearing their
 clothes makes me feel closer to them.
 -You're not a fruit?
 -No, I'm all man. I even fought in World War II. Of course,
 I was wearing women's undergarments under my uniform."

2. "-Detective Vaughn, please remove your hand from my thigh.
 -Okay, where would you like me to put it?
 -How about up your ass?"

3. "-I'm talking about sex, boy. I'm talking about l'amour.
 I'm talking me and Dot are swingers, as in to swing.
 I'm talking what they call nowadays an open marriage."

4. "-The name's Trigger, as in "horse," as in "hung like.""

5. "-So, you just pretend to be an asshole.
 -It's what I'm good at."

6. "-What are we doing here?
 -Well hopefully each other if all goes as planned."

 ANSWER >

1. ED WOOD
 1994, USA
 Director: Tim Burton
 Actor: Johnny Depp, Martin Landau, Sarah Jessica Parker

2. VALENTINE
 2001, USA
 Director: Jamie Blanks
 Actor: Denise Richards, David Boreanaz, Marley Shelton

3. RAISING ARIZONA
 1987, USA
 Director: Joel Coen
 Actor: Nicolas Cage, Holly Hunter, Trey Wilson

4. LIKE FATHER LIKE SON
 1987, USA
 Director: Rod Daniel
 Actor: Dudley Moore, Kirk Cameron, Margaret Colin

5. MAN ON THE MOON
 1999, USA
 Director: Milos Forman
 Actor: Jim Carrey, Danny Devito, Courtney Love

6. NAVY SEALS
 1990, USA
 Director: Lewis Teague
 Actor: Charlie Sheen, Michael Biehn, Joanne Whalley-Kilmer

1. "-I just want to begin by saying to Roosevelt E. Roosevelt, what it is, what it shall be, what it was. The weather out there today is hot and shitty with continued hot and shitty in the afternoon. Tomorrow a chance of continued crappy with a pissy weatherfront coming down from the north. Basically, it's hotter than a snake's ass in a wagon rut."

2. "-You have no values, your whole life is nihilism, cynicism, sarcasm and orgasm.
 -In France I could run on that slogan and win."

3. "-Why do you wanna work on television?
 -I've got to leave my job, because I shagged my boss.
 -Fair enough. Start in Monday."

4. "-You guys aughta be kissing my hairy bean bag!"

5. "-How can you be such an asshole?
 -Practice."

6. "-I will find a substitute for sex. Sex Lite. Sex Helper.
 I Can't Believe It's Not Sex!"

ANSWER >

1. **GOOD MORNING VIETNAM**
 1987, USA
 Director: Barry Levinson
 Actor: Robin Williams, Forest Whitaker, Tung Thanh Tran

2. **DECONSTRUCTING HARRY**
 1997, USA
 Director: Woody Allen
 Actor: Woody Allen, Richard Benjamin, Kirstie Alley

3. **BRIDGET JONES'S DIARY**
 2001, USA
 Director: Sharon Maguire
 Actor: Renee Zellweger, Hugh Grant, Colin Firth

4. **THERE'S SOMETHING ABOUT MARY**
 1998, USA
 Director: Peter Farrelly, Bobby Farrelly
 Actor: Ben Stiller, Cameron Diaz, Matt Dillon

5. **BACKBEAT**
 1993, UNITED KINGDOM
 Director: Iain Softley
 Actor: Stephen Dorff, Sheryl Lee, Ian Hart

6. **JEFFREY**
 1995, USA
 Director: Christopher Ashley
 Actor: Steven Weber, Michael T Weiss, Patrick Stewart

www.nicotext.com

1. "-May I... buy you a drink?
 -I don't see why not. I'm on the pill."

2. "-Tents were sent ahead. Should already be set up by the time
 we get there.
 -Tents?! We're staying in TENTS?!
 -I told you, two days we'd have to camp.
 -Yes! Camp! But I thought that meant Ramada Inn. I never heard
 tents! Will there be toilets?!
 -Maybe we should just take you back.
 -Why? Because I prefer toilets? Maybe I should just wipe myself
 with some leafy little piece of poison oak. And then I can spend
 the whole day scratchin' my ass, blendin' in with the natives."

3. "-Making sex is like a Chinese dinner:
 It ain't over 'til you both get your cookies."

4. "-I got a bad feeling about this.
 -Yeah, me too. Somebody is playing with my dick and it ain't me."

5. "-Does this violate the doctor-patient relationship?
 -Not unless you grab my ass."

6. "-It's faggy without being homosexual."

ANSWER >

1. **LET IT RIDE**
 1989, USA
 Director: Joe Pytka
 Actor: Richard Dreyfuss, Teri Garr, David Johansen

2. **LAKE PLACID**
 1999, USA
 Director: Steve Miner
 Actor: Bill Pullman, Bridget Fonda, Oliver Platt

3. **OUTSIDE PROVIDENCE**
 1999, USA
 Director: Michael Corrente
 Actor: Shawn Hatosy, Jon Abrahams, Alec Baldwin

4. **FALLEN**
 1998, USA
 Director: Gregory Hoblit
 Actor: Denzel Washington, John Goodman,
 Donald Sutherland

5. **GOOD WILL HUNTING**
 1997, USA
 Director: Gus Van Sant
 Actor: Matt Damon, Robin Williams, Ben Affleck

6. **STATE AND MAIN**
 2000, USA
 Director: Davis Mamet
 Actor: Alec Baldwin, William H Macy, Philip Seymour

www.nicotext.com

1. "-There are many different kinds of love, Boris. There's love between a man and a woman; between a mother and son...
 -Two women. Let's not forget my favourite."

2. "-Why are you all shiny?
 -It's Vaseline!
 -Oh ho ohhh! It's Vas...great...it's Vaseline!
 -You've never covered yourself with Vaseline?
 -No, no, not unless I have third degree burns, no."

3. "-Englishmen don't know what a tongue is for."

4. "-Lord, please bless this food, to the nourishment of our bodies. And please Lord, forgive us for the fornication that me and Mr Spock have committed again this morning, on this very table."

5. "-Did you see him? He's probably still scratching his head!
 -Yeah, which must be a nice vacation for his balls."

6. "-Can you give us directions to Mann's Chinese Theatre?
 -Hey! Go back to Iowa!
 -We're from Wisconsin!
 -Yeah, and I'm from my dad's penis."

ANSWER >

1. **LOVE AND DEATH**
 1975, USA
 Director: Woody Allen
 Actor: Woody Allen, Diane Keaton, Harold Gould

2. **STRIPTEASE**
 1996, USA
 Director: Andrew Bergman
 Actor: Demi Moore, Armand Assante, Burt Reynolds

3. **BRAVEHEART**
 1995, USA
 Director: Mel Gibson
 Actor: Mel Gibson, Sophie Marceau, Patrick McGoohan

4. **WHERE THE HEART IS**
 2000, USA
 Director: Matt Williams
 Actor: Natalie Portman, Ashley Judd, Stockard Channing

5. **LEGALLY BLONDE**
 2001, USA
 Director: Robert Luketic
 Actor: Reese Witherspoon, Luke Wilson, Selma Blair

6. **THE ADVENTURES OF FORD FAIRLANE**
 1990, USA
 Director: Renny Harlin
 Actor: Andrew Dice Clay, Wayne Newton, Priscilla Presley

www.nicotext.com

1. "-How about a gross of fluorescent condoms for the novelty machine in the men's room? I mean, those are fun even when you're alone. We're talkin' the hula hoop of the nineties!"

2. "-That's the red-light district. I wonder why Savage is hanging around down there.
-Sex, Frank?
-Uh, no, not right now, Ed."

3. "-You learn anything about proctology yet Patch? Good, take care of this asshole for me, will ya?"

4. "-Look at her would you look at her. She looks like a hooker. Could you love someone who looked like that?
-What are you talking about? Of course not! Five, ten minutes tops, maybe."

5. "-I just didn't want you to think I was like one of your other girls.
-Not much chance of that unless you curtsy on my face real soon."

6. "-What are you girls talking about?
-Cybersex!
-I tried to have cybersex once, but I kept getting a busy signal!"

ANSWER >

1. **KINGPIN**
 1996, USA
 Director: Peter Farrelly, Bobby Farrelly
 Actor: Woody Harrelson, Randy Quaid, Vanessa Angel

2. **THE NAKED GUN 2 1/2: THE SMELL OF FEAR**
 1991, USA
 Director: David Zucker
 Actor: Leslie Nielsen, Priscilla Presley, George Kennedy

3. **PATCH ADAMS**
 1998, USA
 Director: Tom Shadyac
 Actor: Robin Williams, Daniel London, Monica Potter

4. **FLETCH**
 1985, USA
 Director: Michael Ritchie
 Actor: Chevy Chase, Dana Wheeler-Nicholson, Tim Matheson

5. **TERMS OF ENDEARMENT**
 1983, USA
 Director: James L Brooks
 Actor: Shirley McLaine, Debra Winger, Jack Nicholson

6. **YOU'VE GOT MAIL**
 1998, USA
 Director: Nora Ephron
 Actor: Tom Hanks, Meg Ryan, Parker Posey

1. "-Have ya learned your lesson, punk?
 -If the lesson is you're a dick with ears and a really bad haircut,
 yeah, I'd say I've learned my lesson."

2. "-You are not to entertain visitors in your quarters.
 -I'm entertaining you now, aren't I?
 -Yes, but I'm not a beautiful young prospect ripe for corruption.
 -Don't be so sure."

3. "-I will not allow this costume on the air.
 -Why not.
 -Well specifically, you can see her nipples.
 -I want to see her nipples!
 -But this is a Christmas show!
 -Well Charles Dickens would've wanted to see her nipples then."

4. "-Here's 50 bucks,
 take this in case I get drunk and call you a bitch later."

5. "-I was made for lovin' you, baby, you were made for lovin' me!
 -The only way of lovin' me, baby, is to pay a lovely fee!"

6. "-Sex always ends in kids or disease or like,
 you know, relationships."

ANSWER >

1. DETROIT ROCK CITY
 1999, USA
 Director: Adam Rifkin
 Actor: Edward Furlong, Guiseppe Andrews, James De Bello

2. QUILLS
 QUILLS, 2000, USA
 Director: Philip Kaufmann
 Actor: Geoffrey Rush, Kate Winslet, Joaquin Phoenix

3. SCROOGED
 1988, USA
 Director: Richard Donner
 Actor: Bill Murray, Karen Allen, John Forsythe

4. MADE
 2001, USA
 Director: Jon Favreau
 Actor: Vince Vaughn, Jon Favreau, Peter Falk

5. MOULIN ROUGE!
 2001, USA / AUSTRALIEN
 Director: Baz Luhrmann
 Actor: Nicole Kidman, Ewan McGregor, John Leguizamo

6. THE OPPOSITE OF SEX
 1998, USA
 Director: Don Roos
 Actor: Christina Ricci, Martin Donovan, Lisa Kudrow

1. "-...I thought I was going to die.
-Well I'm sorry to disappoint you but you're gonna live to enjoy all the glorious fruits life has got to offer - acne, shaving, premature ejaculation ... and your first divorce."

2. "-She's really a breath of fresh ass.
-What?
-What?
-You said she was fresh ass.
-I did not! I said she was a breast of fresh air, gosh...
-Whatever, let's get some shut ass."

3. "-Maybe it was a dream, you know, a very weird, bizzare, vivid, erotic, wet, detailed dream. Maybe we have malaria."

4. "-Zane, you don't look too good.
-I look like a can of smashed assholes."

5. "-You ain't shit. You just like your daddy.
You don't do shit, and you never gonna amount to shit.
All you do is eat, sleep, and shit."

6. "-Cheating is like playing two games of pool, you got the balls, but you're gonna wear out the stick."

1. **LAST ACTION HERO**
 1993, USA
 Director: John McTiernan
 Actor: Arnold Schwarzenegger, F Murray Abraham, Art Carney

2. **WILD WILD WEST**
 1999, USA
 Director: Barry Sonnenfeld
 Actor: Will Smith, Kevin Kline, Kenneth Branagh

3. **WEIRD SCIENCE**
 1985, USA
 Director: John Hughes
 Actor: Anthony Michael Hall, Kelly LeBrock, Ilan Mitchell-Smith

4. **THE ARRIVAL**
 1996, USA
 Director: Davis Twohy
 Actor: Charlie Sheen, Ron Silver, Lindsay Crouse

5. **BOYZ N THE HOOD**
 1991, USA
 Director: John Singleton
 Actor: Larry Fishburne, Ice Cube, Cuba Gooding Jr.

6. **STRAIGHT TALK**
 1992, USA
 Director: Barnet Kellman
 Actor: Dolly Parton, James Woods, Griffin Dunne

1. "-Are you actually enjoying this?
 -Well it's better then my average day...reading philosophy
 and trying not to get raped in the wash room, of course
 that hasn't been much of a problem anymore...
 I think I may be losing my sex appeal."

2. "-I was married. My husband cheated on me left and right. One
 day he tells me it's MY fault he saw other women. So I picked
 up a knife, and told him it was HIS fault I was stabbing him."

3. "-I'd like a Long Island iced tea, please.
 -Is that a good idea, for the baby?
 -Oh, please. This baby owes its life to Long Island iced teas,
 if you know what I mean."

4. "-You dream that if you discuss the revolution with a man before
 you go to bed with him, it'll be missionary work rather than sex."

5. "-Give it up, Vacendak. You couldn't catch a cold.
 You couldn't catch the clap in a whorehouse!"

6. "-The World will want to know what you're thinking.
 -Fuck! is what I'm thinking!
 -Good...The world will want to know that."

 ANSWER >

1. THE ROCK
 1996, USA
 Director: Michael Bay
 Actor: Sean Connery, Nicholas Cage, Ed Harris

2. LIVING OUT LOUD
 1998, USA
 Director: Richard LaGravenese
 Actor: Holly Hunter, Danny DeVito, Queen Latifah

3. THE OPPOSITE OF SEX
 1998, USA
 Director: Don Roos
 Actor: Christina Ricci, Martin Donovan, Lisa Kudrow

4. REDS
 1981, USA
 Director: Warren Beatty
 Actor: Warren Beatty, Diane Keaton, Edward Herrmann

5. FREEJACK
 1992, USA
 Director: Geoff Murphy
 Actor: Emilio Estevez, Mick Jagger, Reneé Russo

6. THE FLY
 1986, USA
 Director: David Cronenberg
 Actor: Jeff Goldblum, Geena Davis, John Getz

1. "-Einstein's theory of relativity. Put your hands on a hot pan, a second can seem like an hour. Grab hold of a hot woman, an hour can seem like a second, it's all relative.
-You know, I spent four years at Cal Tech, and that's the best physics explanation I've ever heard."

2. "-The sex is so, so fan - fucking - tastic!
Anyway that's what he calls it."

3. "-The male erection. Pitchin' a tent, sportin' a wood, stiffie, flesh rocket, tall tommy, Mr. Morbis, the march is on, icycle has formed, Jack's magic beanstalk, rigor mortis has set in, Mr. Mushroom-head, mushroom on a stick, purple headed yogurt slinger... oh, and a pedro."

4. "-These boys are promising young men. Acquiring an education.
-Well, I've had you pegged as the type that likes... educatin' young men."

5. "-God damn! That thing's got more holes than my daddy's rubber."

6. "-I am the master of the clit."

ANSWER >

1. **DEEP BLUE SEA**
 1999, USA
 Director: Renny Harlin
 Actor: Thomas Jane, Saffron Burrows, Samuel L Jackson

2. **TERMS OF ENDEARMENT**
 1983, USA
 Director: James L Brooks
 Actor: Shirley McLaine, Debra Winger, Jack Nicholson

3. **VARSITY BLUES**
 1999, USA
 Director: Brian Robbins
 Actor: James Van Der Beek, Jon Voight, Paul Walker

4. **YOUNG GUNS**
 1988, USA
 Director: Christopher Cain
 Actor: Emilio Estevez, Kiefer Sutherland, Lou Diamond Phillips

5. **BLIND FURY**
 1989, USA
 Director: Philip Noyce
 Actor: Rutger Hauer, Terrance (Terry) O'Quinn, Brandon Call

6. **JAY AND SILENT BOB STRIKE BACK**
 2001, USA
 Director: Kevin Smith
 Actor: Jason Mewes, Kevin Smith, Ben Affleck

1. "-You gotta help me. Lisa is all primed but her helpful friend, fat Rita, will take her home unless she gets some action too.
-OK, first of all, I'm way too wasted to be operating heavy machinery. And second of all, I got this spinner all G-ed out. She's liquid.
-Leave her on the back burner. Take one for the team."

2. "-I'll never forget what my Uncle Moe said about little girls. He said, "Officer, she said she was 18!""

3. "-PROSTITUTION! But what does that mean really?
Let's break up the word. First there's Pros... well, that doesn't mean anything really... then there's Tit... we all know what that means... and then there's "shun" to shun is to say No! To push it away! To shun something is, well... it really doesn't belong in this word at all, really."

4. "-What are you guys celebrating?
-Life, liberty, and the pursuit of the clitoris."

5. "-22 years. Man, L.A. has changed a lot during that time. The air got dirty and the sex got clean."

6. "-I'm an old-fashioned girl. I like to make it in bed."

ANSWER >

1. **LOSER**
 2000, USA
 Director: Amy Heckerling
 Actor: Jason Biggs, Mena Suvari, Zak Orth

2. **MR. SATURDAY NIGHT**
 1992, USA
 Director: Billy Crystal
 Actor: Billy Crystal, David Paymer, Julie Warner

3. **NIGHT SHIFT**
 1982, USA
 Director: Ron Howard
 Actor: Henry Winkler, Michael Keaton, Shelley Long

4. **PROOF OF LIFE**
 2000, USA
 Director: Taylor Hackford
 Actor: Meg Ryan, Russell Crowe, David Morse

5. **POINT BREAK**
 1991, USA
 Director: Kathryn Bigelow
 Actor: Patrick Swayze, Keanu Reeves, Gary Busey

6. **THE HAND**
 1981, USA
 Director: Oliver Stone
 Actor: Michael Caine, Andrea Marcovicci, Annie McEnroe

1. "-Uh, Lord, hallowed be Thy name. May our feet be swift; may our bats be mighty; may our balls... be plentiful. Lord, I'd just like to thank You for that waitress in South Bend. You know who she is - she kept calling Your name."

2. "-We're finished! It's over between us!
-But why?
-You slept with Jiff.
-So?
-You know, I never thought about it that way.
-So I'll see you tonight?
-What time?"

3. "-He had a gorgeous mistress and he went with an ugly whore?
-You know, there are some things even mistresses won't do.
-Like what?
-I am not telling."

4. "-With your wife in bed, does she need some kind of artificial stimulation, like, like marijuana?
-We use a large vibrating egg."

5. "-This is the most pathetic sexual fantasy I've ever seen."

6. "-I think sexual intercourse is in order Gilbert."

 ANSWER >

1. **A LEAGUE OF THEIR OWN**
1992, USA
Director: Penny Marshall
Actor: Tom Hanks, Geena Davis, Madonna

2. **BOWFINGER**
1999, USA
Director: Frank Oz
Actor: Steve Martin, Eddie Murphy, Heather Graham

3. **REVERSAL OF FORTUNE**
1990, USA
Director: Barbet Schroeder
Actor: Glenn Close, Jeremy Irons, Ron Silver

4. **ANNIE HALL**
1977, USA
Director: Woody Allen
Actor: Woody Allen, Diane Keaton, Tony Roberts

5. **MY BOYFRIEND'S BACK**
1993, USA
Director: Bob Balaban
Actor: Andrew Lowery, Traci Lind, Danny Zorn

6. **A PRIVATE FUNCTION**
1985, UNITED KINGDOM
Director: Malcolm Mowbray
Actor: Michael Palin, Maggie Smith, Liz Smith

1. "-The good news is that your Blue Cross will cover this visit. The bad news is that you have herpes simplex I and II, trichomonas, gonorrhea, acute immune deficiency syndrome related complex, vulvar lesions, secondary syphilis, venereal warts, and a potentially unbearable case of crabs."

2. "-You know, Antoine's got a really bad temper. One time, I dropped a cigar ash on his carpet, and he made me pick it up with my anus."

3. "-You wanna get high?
-Does howdy doody have wooden balls?"

4. "-I'm a sex object! When I ask women for sex they object."

5. "-Oh! How can I ever thank you?
-Can I squeeze your titties?"

6. "-No grief for Lips?
-I'm wearing black underwear.
-You know, it's legal for me to take you down to the station and sweat it out of you under the light.
-I sweat a lot better in the dark."

ANSWER >

NICOS Dirty - MovieQouteBook

1. **CASUAL SEX**
 1988, USA
 Director: Genevieve Robert
 Actor: Lea Thompson, Victoria Jackson, Stephen Shellen

2. **DEUCE BIGALOW: MALE GIGOLO**
 1999, USA
 Director: Mike Mitchell
 Actor: Rob Schneider, William Forsythe, Eddie Griffin

3. **UP IN SMOKE**
 1978, USA
 Director: Lou Adler
 Actor: Cheech Marin, Tommy Chong, Stacy Keach

4. **THEY CALL ME BRUCE**
 1982, USA
 Director: Elliot Hong
 Actor: Johnny Yune, John Louie, Bill Capizzi

5. **BASQUIAT**
 1996, USA
 Director: Julian Schnabel
 Actor: Jeffrey Wright, David Bowie, Dennis Hopper

6. **DICK TRACY**
 1990, USA
 Director: Warren Beatty
 Actor: Warren Beatty, Madonna, Al Pacino

1. "-Are they gonna be okay with you being a white guy?
-According to her they'll be happy that I'm a man. Apparently they think any woman over 30 who isn't married is a lesbian.
-Yeah its always heartwarming to see a prejudice defeated by a deeper prejudice."

2. "-You gotta have two things to win. You gotta have brains and you gotta have balls. And you got too much of one and not enough of the other."

3. "-I can't come to the phone right now, I'm eating corn chips and masturbating. Please leave a message."

4. "-No! No! No! Hold the bow like this! Not like this! This isn't your dick you're holding! It's a violin bow! Hold it with respect, like...
- ...Your dick?"

5. "-Hey, don't knock masturbation. It's sex with someone I love."

6. "-I was looking for some stamps.
-Yeah I have some right here. Are you gonna send a letter to a friend back east?
-No I was thinking about sending away for an inflatable date."

ANSWER >

1. **LONE STAR**
 1996, USA
 Director: John Sayles
 Actor: Kris Kristofferson, Chris Cooper, Elisabeth Pena

2. **THE COLOR OF MONEY**
 1986, USA
 Director: Martin Scorsese
 Actor: Paul Newman, Tom Cruise, Mary Elisabeth Mastrantonio

3. **HARD CORE LOGO**
 1996, CANADA
 Director: Bruce McDonald
 Actor: Hugh Dillon, Callum Keith Rennie, John Pyper-Ferguson

4. **FAME**
 1980, USA
 Director: Alan Parker
 Actor: Irene Cara, Lee Curreri, Eddie Barth

5. **ANNIE HALL**
 1977, USA
 Director: Woody Allen
 Actor: Woody Allen, Diane Keaton, Tony Roberts

6. **PUMP UP THE VOLUME**
 1990, USA
 Director: Allan Moyle
 Actor: Christian Slater, Ellen Greene, Annie Ross

1. "-Maybe what he need is for you to pop your
titty out his mouth and let the boy grow up.
-Excuse me, what did you say?
-I didn't stutter, I said pop-your-titty-out-his-mouth
AND STOP BABYING HIM.
-I don't call it babying, I call it nurturing.
-And I call it nutering.
-And I call you an insecure, overbaring, psychopathic,
edictorial, ego maniacle, frigid lunatic ASSHOLE!!
-I ain't frigid."

2. "-Well Mr. Phipps, you are in perilous danger
of turning me back into a heterosexual."

3. "-You ever read about yourself in the newspaper?
Your balls shrivel to the size of chick-peas!"

4. "-You had sex with my prom date!
-She wasn't your prom date.
-Not after you had sex with her."

5. "-In fact, civilization and syphilization have advanced together."

6. "-I wonder if she actually had an orgasm in the two
years we were married, or did she fake it that night?"

ANSWER >

1. **MAJOR PAYNE**
1995, USA
Director: Nick Castle
Actor: Rodney P. Barnes, Damon Wayans, Ross Bickell

2. **MAYBE BABY**
2000, UNITED KINGDOM
Director: Ben Elton
Actor: Joely Richardson, Matthew MacFadyen, Hugh Laurie

3. **KISS OF DEATH**
1995, USA
Director: Barbet Schroeder
Actor: David Caruso, Nicholas Cage, Samuel L Jackson

4. **STEALING HOME**
1988, USA
Director: Steven Kampmann, Will Aldis
Actor: Mark Harmon, Jodie Foster, William McNamara

5. **BRAM STOKER'S DRACULA**
1992, USA
Director: Francis Ford Coppola
Actor: Gary Oldman, Winona Ryder, Anthony Hopkins

6. **PLAY IT AGAIN SAM**
1972, USA
Director: Herbert Ross
Actor: Woody Allen, Diane Keaton, Tony Roberts

1. "-I have to admit, you know, I did the fair bit of... masturbating when I was a little younger. I used to call it stroking the salami, yeah, you know, pounding the old pud... I never did it with baked goods, but you know your uncle Mort, he pets the one-eyed snake 5-6 times a day."

2. "-And I'm wondering: how did it all slip away?
-Well, it didn't slip away, Martin. You did, when you went off to fuck Nicky at my birthday party.
-Yeah, that was a good party."

3. "-Tell Victor that Ramon... The fella he met about a week ago? Tell him that Ramon went to the clinic today, and I found out that I have, um, herpes simplex 10, and I think Victor should go check himself out with his physician to make sure everything is fine before things start falling off on the man."

4. "-Bridget Jones, wanton sex goddess, with a very bad man between her thights,... Dad!...Hi."

5. "-Sex is kinda like pizza. When it's bad, it's still pretty good."

6. "-Are you now, or have you ever been a homosexual?"

ANSWER >

1. **AMERICAN PIE**
 1999, USA
 Director: Paul Weitz
 Actor: Jason Biggs, Shannon Elizabeth, Alyson Hannigan

2. **GET SHORTY**
 1995, USA
 Director: Barry Sonnenfeld
 Actor: John Travolta, Gene Hackman, Rene Russo

3. **BEVERLY HILLS COP**
 1984, USA
 Director: Martin Brest
 Actor: Eddie Murphy, Judge Reinhold, John Ashton

4. **BRIDGET JONES'S DIARY**
 2001, USA
 Director: Sharon Maguire
 Actor: Renee Zellweger, Hugh Grant, Colin Firth

5. **THREESOME**
 1994, USA
 Director: Andrew Fleming
 Actor: Lara Flynn Boyle, Stephen Baldwin, Josh Charles

6. **A CLOCKWORK ORANGE**
 1971, USA
 Director: Stanley Kubrick
 Actor: Malcolm McDowell, Patrick Magee, Adrienne Corri

1. "-I'll do anything sexual.
 I don't need a million dollars to do it either.
 -You're lying.
 -I already have. I've done just about everything there is except
 a few things that are illegal. I'm a nymphomaniac.
 -Lier.
 -Are your parents aware of this?
 -The only person I told was my shrink.
 -And what did he do when you told him?
 -He nailed me.
 -Very nice.
 -I don't think that from a legal standpoint what he did can be
 construed as rape, since I paid him."

2. "-My motto is you should make a point of trying everything once,
 except incest... and folkdancing."

3. "-Like a blind man at an orgy,
 I was going to have to feel my way through."

4. "-I'm just a sweet transvestite, from Transsexual Transylvania."

5. "-Clitorissimo!"

6. "-Is that legal...having sex with a kangaroo?"

ANSWER >

1. THE BREAKFAST CLUB
 1985, USA
 Director: John Hughes
 Actor: Emilio Esteves, Judd Nelson, Molly Ringwald

2. LOVE AND OTHER CATASTROPHES
 1996, AUSTRALIA
 Director: Emma-Kate Croghan
 Actor: Matt Day, Matthew Dyktynski, Alice Garner

3. NAKED GUN 33 1/3: THE FINAL INSULT
 1994, USA
 Director: Peter Segal
 Actor: Leslie Nielsen, Priscilla Presley, George Kennedy

4. THE ROCKY HORROR PICTURE SHOW
 1975, UNITED KINGDOM
 Director: Jim Sharman
 Actor: Tim Curry, Susan Sarandon, Barry Bostwick

5. ROGER DODGER
 2002, USA
 Director: Dylan Kidd
 Actor: Campbell Scott, Jesse Eisenberg, Isabella Rossellini

6. I LOVE YOU TO DEATH
 1990, USA
 Director: Lawrence Kasdan
 Actor: Kevin Kline, Tracy Ullman, River Phoenix

1. "-I don't know what I hate wearing worse. Your face or your body. I mean I certainly do enjoy boning your wife, but let's face it, we both like it better the other way yes? So why don't we trade back.!"

2. "-I saw Mr. Riddle in his backyard, he was watching me.
 -Mr. Riddle was watching you? Laurie! Mr. Riddle is eighty-seven!
 -He can still watch.
 -That's probably all he can do."

3. "-I can't do this without you. I'm afraid he might pull the stiff one-eye on me."

4. "-It could have been worse.
 -Yes, Sarah. It could have been worse.
 They could have attached electrodes to our genitals."

5. "-I had a hard-on this morning and it had your name written on it.
 -My name's four letters - there ain't enough room on your joint to fit it."

6. "-How could you do this? A total stranger I could understand. You and another woman, maybe. Me, you and another woman, definitely! But my own brother?"

ANSWER >

1. **FACE/OFF**
1997, USA
Director: John Woo
Actor: John Travolta, Nicholas Cage, Joan Allen

2. **HALLOWEEN**
1978, USA
Director: John Carpenter
Actor: Donald Pleasence, Jamie Lee Curtis, Nancy Loomis

3. **AS GOOD AS IT GETS**
1997, USA
Director: James L Brooks
Actor: Jack Nickolson, Helen Hunt, Greg Kinnear

4. **PETER'S FRIENDS**
1992, UNITED KINGDOM
Director: Kenneth Branagh
Actor: Kenneth Branagh, Emma Thompson, Rita Rudner

5. **A NIGHTMARE ON ELM STREET**
1984, USA
Director: Wes Craven
Actor: John Saxon, Ronee Blakley, Heather Langenkamp

6. **JANE AUSTEN'S MAFIA!**
1998, USA
Director: Jim Abrahams
Actor: Jay Mohr, Billy Burke, Christina Applegate

1. "-When I met Mary, I got that old fashioned romantic feeling,
 where I'd do anything to bone her.
 -That's a special feeling."

2. "-What does he like?
 -14-year old girls.
 -Well get him something else. We want to get out of this
 town alive. Get him half a 28-year old girl."

3. "-If it looks like shit, and it sounds like shit, than it must be shit."

4. "-I think you're some kind of deviated pervert. I think general
 ripper found out about your preversion, and that you were
 organizing some kind of mutiny of perverts."

5. "-Would you like to turn on the Jacuzzi sir?
 -Man I knew you all faggots.
 -It's a whirlpool bath sir. I think you'll enjoy it.
 -Hey! Bubbles! Man when we was kids and we wanted
 bubbles we had to fart in the tub!"

6. "-Ms. Stoeger, my plastic surgeon doesn't want me doing
 any activity where balls fly at my nose.
 -Well, there goes your social life."

ANSWER >

1. **DUMB & DUMBER**
 1994, USA
 Director: Peter Farrelly
 Actor: Jim Carrey, Jeff Daniels, Lauren Holly

2. **STATE AND MAIN**
 2000, USA
 Director: Davis Mamet
 Actor: Alec Baldwin, William H Macy, Philip Seymour

3. **BOOGIE NIGHTS**
 1997, USA
 Director: Paul Thomas Anderson
 Actor: Mark Wahlberg, Burt Reynolds, Julianne Moore

4. **DR STRANGELOVE OR: HOW I LEARNED TO STOP
 WORRING AND LOVE THE BOMB**
 1964, UNITED KINGDOM
 Director: Stanley Kubrick
 Actor: Peter Sellers, George C Scott, Sterling Hayden

5. **TRADING PLACES**
 1983, USA
 Director: John Landis
 Actor: Dan Aykroyd, Eddie Murphy, Ralph Bellamy

6. **CLUELESS**
 1995, USA
 Director: Amy Heckerling
 Actor: Alicia Silverstone, Stacey Dash, Brittany Murphy

www.nicotext.com

1. "-Hal, don't you think you're being a bit shallow here in
 the way you look at women?
 -Well, no! You know, I'd like her to be into culture and shit, too.
 -Well, let me ask you. Which would you prefer - a girl missing
 a breast or missing half her brain?
 -Hmmm, toughie. What about the other breast? Is it big?"

2. "-If any of you so much as pass gas in my direction
 and upset my delicate nasal passages, your testicles
 will become my private property."

3. "-Leo Getz, private investigator.
 -Ah, private investigator? Yes, Mr. Getz, I was just
 wondering if you'd be willing to investigate my privates.
 -Investigate what?
 -Investigate my privates, you stupid shit."

4. "-"Captain Hauk sucks the sweat off of a dead mans balls."
 I have no idea what that means, but it seems very negative
 to me."

5. "-I want it to be the right time, the right place...
 -It's not a space shuttle launch, it's SEX."

6. "-Listen, you daughter! I have your asshole!"

ANSWER >

1. **SHALLOW HAL**
 2001, USA
 Director: Bobby Farrelly, Peter Farrelly
 Actor: Gwyneth Paltrow, Jack Black, Jason Alexander

2. **CON AIR**
 1997, USA
 Director: Simon West
 Actor: Nicolas Cage, John Cusack, John Malkovich

3. **LETHAL WEAPON 4**
 1998, USA
 Director: Richard Donner
 Actor: Mel Gibson, Danny Glover, Joe Pesci

4. **GOOD MORNING VIETNAM**
 1987, USA
 Director: Barry Levinson
 Actor: Robin Williams, Forest Whitaker, Tung Thanh Tran

5. **AMERICAN PIE**
 1999, USA
 Director: Paul Weitz
 Actor: Jason Biggs, Shannon Elizabeth, Alyson Hannigan

6. **A LIFE LESS ORDINARY**
 1997, UNITED KINGDOM/USA
 Director: Danny Boyle
 Actor: Ewan McGregor, Cameron Diaz, Holly Hunter

www.nicotext.com

1. "-How are we this morning, Counselor?
 -Fine, thank you.
 -And how about you, Mr. Reede?
 -I'm a little upset about a bad sexual episode I had last night.
 -Well, you're young. It'll happen more and more.
 In the meantime, what do you say we get down to business?"

2. "-No, I'll join this converation on the proviso that we stop bitching about people talking about wigs, dresses, bust sizes, penises, drugs, night clubs, and bloody Abba!
 -Doesn't give us much to talk about then, does it?"

3. "-If the Mario brothers weren't New Jersey's third-largest crime family, I'd say, "Kiss my ass." But considering your status, I will say, "Slurp my butt."."

4. "-I thought, that maybe, if I could light my farts, I could fly to the moon, or at least Uranus. If not, I could always use my penis as a pogo stick and that might be a way of getting oround."

5. "-If a man ever bought that for me, not only would I have sex with him, but I would ENJOY it!"

6. "-Welcome to my submarine lair!
 It's long, hard and full of seamen."

ANSWER >

1. **LIAR LIAR**
 1997, USA
 Director: Tom Shadyac
 Actor: Jim Carrey, Maura Tierney, Jennifer Tilly

2. **THE ADVENTURES OF PRISCILLA, QUEEN OF THE DESERT**
 1994, AUSTRALIA
 Director: Stephan Elliot
 Actor: Terence Stamp, Hugo Weaving, Guy Pearce

3. **HUDSON HAWK**
 1991, USA
 Director: Michael Lehmann
 Actor: Bruce Willis, Danny Aiello, Andie MacDowell

4. **PATCH ADAMS**
 1998, USA
 Director: Tom Shadyac
 Actor: Robin Williams, Daniel London, Monica Potter

5. **ISN'T SHE GREAT**
 2000, USA
 Director: Andrew Bergman
 Actor: Bette Midler, Nathan Lane, Stockhard Channing

6. **AUSTIN POWERS IN GOLDMEMBER,**
 2002, USA
 Director: Jay Roach
 Actor: Mike Myers, Michael Caine, Beyonce Knowles

1. "-Everything was fine, until dickless here cut off the power grid!
 -Is that true?
 -Yes, Your Honor, this man has no dick."

2. "-It's every man's right to have babies if he wants them.
 -But you can't have babies.
 -Don't you oppress me.
 -I'm not oppressing you, Stan - you haven't got a womb.
 Where's the fetus going to gestate? You going to keep it
 in a box?"

3. "-What the hell was that noise?
 -That was my virgin-alarm. It's programmed to go off
 before you do!"

4. "-What's the deal on this 57 Chev?
 For 1500, old man...She ought to run like a wet dream."

5. "-Had my dream again where I'm making love, and the Olympic
 judges are watching. I'd nailed the compulsories, so this is it,
 the finals. I got a 9.8 from the Canadians, a perfect 10 from the
 Americans, and my mother, disguised as an East German judge,
 gave me a 5.6. Must have been the dismount."

6. "-You know, you make a funny face when you come."

ANSWER >

1. GHOSTBUSTERS
 1984, USA
 Director: Ivan Reitman
 Actor: Bill Murray, Dan Aykroyd, Harold Ramis

2. MONTY PYTHON'S LIFE OF BRIAN
 1979, UNITED KINGDOM
 Director: Terry Jones
 Actor: Graham Chapman, John Cleese, Terry Gilliam

3. SPACEBALLS
 1987, USA
 Director: Mel Brooks
 Actor: Mel Brooks, John Candy, Rick Moranis

4. USED CARS
 1980, USA
 Director: Robert Zemeckis
 Actor: Kurt Russell, Jack Warden, Gerrit Graham

5. WHEN HARRY MET SALLY
 1989, USA
 Director: Rob Reiner
 Actor: Billy Cristal, Meg Ryan, Carrie Fisher

6. BAD INFLUENCE
 1990, USA
 Director: Curtis Hanson
 Actor: Rob Lowe, James Spader, Lisa Zana

www.nicotext.com

1. "-So you're the little neighborhood Lolita.
 -So you're the alcoholic high school buddy shit for brains."

2. "-I like you, I don't know what it is about you.
 -My tits?
 -No! No, no, no.
 -No?
 -It's your energy, your attitude, you know, the way you
 carry yourself.
 -You're not a fag, are you?
 -No, I am really attracted to you.
 -"No, I am really attracted to you", Christ, you are a fag.
 Okay, we can share recipes if you like, darling.
 -No, no, I love your tits, love 'em, I wanna fondle 'em.
 -Great, now we're getting somewhere. Not a chance."

3. "-Nobody fucks with me!
 -Well, maybe if you find the right girl."

4. "-I need to get laid; my right hand is so tired I can't thread
 a needle."

5. "-If you are going to be going...
 -Might as well be coming."

6. "-Casey, where did you find this man? Is there an asshole
 convention in town?"

ANSWER >

1. **BEAUTIFUL GIRLS**
 1996, USA
 Director: Ted Demme
 Actor: Matt Dillon, Noah Emmerich, Annabeth Gish

2. **BEING JOHN MALKOVICH**
 1999, USA
 Director: Spike Jonze
 Actor: John Cusack, John Malkovich, Cameron Diaz

3. **BLUE VELVET**
 1986, USA
 Director: David Lynch
 Actor: Kyle MacLachlan, Isabella Rossellini, Dennis Hopper

4. **SHOWGIRLS**
 1995, USA
 Director: Paul Verhoeven
 Actor: Elisabeth Berkley, Kyle MacLachlan, Gina Gershon

5. **LAST NIGHT**
 1998, CANADA
 Director: Don McKellar
 Actor: Don McKellar, Sandra Oh, Roberta Maxwell

6. **MOVING**
 1988, USA
 Director: Alan Metter
 Actor: Richard Pryor, Beverly Todd, Stacey Dash

1. "-Austin, I think I was paranoid about you and Alotta Fagina.
 -No, you're right I nailed the bird.
 -Did you used protection?
 -Yeah, I had my 9mm with me.
 -No, I mean a condom.
 -Only sailors wear condoms baby.
 -Not in the '90s Austin.
 -Well they should, those filthy beggars go from port to port."

2. "-For me, love is very deep, but sex only has to go a few inches."

3. "-She's a babe.
 -She's magically babelicious.
 -She tested very high on the stroke-ability scale."

4. "-My psychiatrist asked me if I thought sex was dirty and
 I said it is if you're doing it right."

5. "-Remember that time we danced at the sock hop?
 -Yeah.
 -I just wanted you to know I had the hugest boner and I was
 just wondering if maybe you and I could get together and...
 work it out."

6. "-Hey, baby. You wanna see what's hanging?"

ANSWER >

1. **AUSTIN POWERS: INTERNATIONAL MAN OF MYSTERY**
1997,USA
Director: Jay Roach
Actor: Mike Myers, Elizabeth Hurley, Michael York

2. **BULLETS OVER BROADWAY**
1994, USA
Director: Woody Allen
Actor: John Cusack, Dianne Wiest, Jennifer Tilly

3. **WAYNE'S WORLD**
1992, USA
Director: Penelope Spheeris
Actor: Mike Myers, Dana Carvey, Rob Lowe

4. **TAKE THE MONEY AND RUN**
1969, USA
Director: Woody Allen
Actor: Woody Allen, Janet Margolin, Marcel Hillaire

5. **CAN'T HARDLY WAIT**
1998, USA
Director: Deborah Kaplan
Actor: Ethan Embry, Charlie Korsmo, Lauren Ambrose

6. **THE OUTSIDERS**
1983, USA
Director: Francis Ford Coppola
Actor: Thomas Howell, Matt Dillon, Ralph Macchio

1. "-Miss, I really, really lick you
 "Like" you. I didn't mean to say that."

2. "-Would you call Langley? We're still waiting on a psych
 profile on Kodorov.
 -He's an asshole. Save you the trip.
 -Thanks, I'll settle for the official version.
 -OK, officially -- he's an asshole!"

3. "-I am a gay lesbian woman!
 I do not mythologize the male sexual organ!"

4. "-My daddy used to spank my bare bottom.
 Now he's gone. Will you take his place?"

5. "-You slept with a sixty year old??
 -Hey, when you work in the physical therapy industry...
 you make friends fast."

6. "-He's got this thing.
 -It's a vibrator I carry around with me.
 -You carry a vibrator around with you?
 -Yeah. As a form of come-on. So the girls can see
 I'm up for anything right away. Sometimes as a sort
 of, uh, mood-setter I turn it on."

ANSWER >

1. PEARL HARBOUR
 2001, USA
 Director: Michael Bay
 Actor: Ben Affleck, Josh Hartnett, Kate Beckinsale

2. THE PEACEMAKER
 1997, USA
 Director: Mimi Leder
 Actor: George Clooney, Nicole Kidman,
 Armin Mueller-Stahl

3. PRIMARY COLORS
 1998, USA
 Director: Mike Nichols
 Actor: John Travolta, Emma Thompson, Kathy Bates

4. RISKY BUSINESS
 1983, USA
 Director: Paul Brickman
 Actor: Tom Cruise, Rebecca De Mornay, Curtis Armstrong

5. DOWN TO YOU
 2000, USA
 Director: Kris Isacsson
 Actor: Freddie Prinze Jr, Julia Stiles, Selma Blair

6. HURLYBURLY
 1998, USA
 Director: Anthony Drazan
 Actor: Sean Penn, Kevin Spacey, Robin Wright

www.nicotext.com

1. "-Could you have ruined yourself somehow?
 -How could I ruin myself?
 -I don't know. Excessive masturbation?
 -You gonna start knockin' my hobbies?"

2. "-Holy dog shit! Texas? Only steers and queers come from Texas, Private Cowboy. And you don't look much like a steer to me, so that kinda narrows it down."

3. "-How wasted were we last night?
 -Well, I touched Christy Boner's hoo-hoo, were on the hook for two hundred thousand dollars to a transsexual stripper, and my car's gone. I'd say we were pretty wasted."

4. "-What the hell's going on down there? We need an erection!"

5. "-Shel? Sheldon? No. You did not have great sex with Sheldon.
 -I did too.
 -No. A Sheldon can do your income taxes. If you need a root canal, Sheldon's your man. But humping and pumping are not Sheldon's strong suits. It's the name. Do it to me, Sheldon. You're an animal, Sheldon. Ride me, big Sheldon.
 It doesn't work."

6. "-Would you like to touch my penis? I am a sex machine!"

ANSWER >

1. **HANNAH AND HER SISTERS**
 1986, USA
 Director: Woody Allen
 Actor: Woody Allen, Michael Caine, Mia Farrow

2. **FULL METAL JACKET**
 1987, UNITED KINGDOM
 Director: Stanley Kubrick
 Actor: Matthew Modine, Adam Baldwin,
 Vincent D'Onofrio

3. **DUDE, WHERE'S MY CAR?**
 2000, USA
 Director: Danny Leiner
 Actor: Aston Kutcher, Sean William Scott, Kristy Swanson

4. **EVERYTHING YOU ALWAYS WANTED
 TO KNOW ABOUT SEX BUT WERE AFRAID TO ASK**
 1972, USA
 Director: Woody Allen
 Actor: Woody Allen, John Carradine, Lou Jacobi

5. **WHEN HARRY MET SALLY**
 1989, USA
 Director: Rob Reiner
 Actor: Billy Cristal, Meg Ryan, Carrie Fisher

6. **CAN'T HARDLY WAIT**
 1998, USA
 Director: Deborah Kaplan
 Actor: Ethan Embry, Charlie Korsmo, Lauren Ambrose

1. "-Was it ticking?
 -Actually throwers don't worry about ticking 'cause modern
 bombs don't tick.
 -Sorry, throwers?
 -Baggage handlers. But, when a suitcase vibrates, then the
 throwers gotta call the police.
 -My suitcase was vibrating?
 -Nine times out of ten it's an electric razor, but every once
 in a while...It's a dildo. Of course it's company policy never to,
 imply ownership in the event of a dildo... always use the indefinite
 article "a dildo", never "your dildo"."

2. "-So you're the fat fuck who's running the show?
 -Well-spoken Mr Karew, you're obviously a poet,
 a man after my own heart."

3. "-God gave men brains larger than dogs' so they wouldn't
 hump women's legs at cocktail parties."

4. "-Meet me in the bedroom in five minutes,
 and bring a cattle prod."

5. "-Never trust anything that can bleed for a week and not die."

6. "-Felicity Shagwell. Shagwell by name,
 shag-very-well by reputation."

ANSWER >

1. **FIGHT CLUB**
 1999, USA
 Director: David Fincher
 Actor: Brad Pitt, Edward Norton, Helena Bonham Carter

2. **SEE NO EVIL, HEAR NO EVIL**
 1989, USA
 Director: Arthur Hiller
 Actor: Richard Pryor, Gene Wilder, Joan Severance

3. **HACKERS**
 1995, USA/UNITED KINGDOM
 Director: Iain Softley
 Actor: Jonney Lee Miller, Angelina Jolie, Fisher Stevens

4. **WHAT'S UP TIGER LILY?**
 1966, JAPAN
 Director: Senkichi Taniguchi
 Actor: Tatsuya Mihashi, Miya Hana, Eiko Wakabayashi

5. **IN THE COMPANY OF MEN**
 1997, USA
 Director: Neil LaBute
 Actor: Aaron Eckhart, Stacy Edwards, Matt Malloy

6. **AUSTIN POWERS: THE SPY WHO SHAGGED ME**
 1999, USA
 Director: Jay Roach
 Actor: Mike Myers, Heather Graham, Rob Lowe

1. "-I eat pieces of shit like you for breakfast!
 -You eat pieces of shit for breakfast?
 -No!... I...!"

2. "-What would you do if you had a million dollars?
 -I'll tell you what I'd do, man, two chicks at the same time, man.
 -That's it? If you had a million dollars, you'd do two chicks at the same time?
 -Damn straight. I always wanted to do that, man. And I think if I had a million dollars I could hook that up, cause chicks dig a dude with money.
 -Well, not all chicks.
 -Well the kind of chicks that'd double up on me do.
 -Good point."

3. "-I can't figure out if you're a detective or a pervert.
 -Well, that's for me to know and you to find out."

4. "-Without them, you are a walking lightbulb, just waiting to be screwed."

5. "-Boy, you're gonna be busier than a three-peckered goat."

6. "-Call me old-fashioned, but I like my women live and direct."

ANSWER >

1. **HAPPY GILMORE**
 1996, USA
 Director: Dennis Dugan
 Actor: Adam Sandler, Christopher McDonald, Julie Bowen

2. **OFFICE SPACE**
 1999, USA
 Director: Mike Judge
 Actor: Ron Livingston, Jennifer Aniston, David Herman

3. **BLUE VELVET**
 1986, USA
 Director: David Lynch
 Actor: Kyle MacLachlan, Isabella Rossellini, Dennis Hopper

4. **FOUL PLAY**
 1978, USA
 Director: Colin Higgins
 Actor: Goldie Hawn, Swoozie Kurtz, Robyn Lively

5. **FIRE BIRDS**
 1990, USA
 Director: David Green
 Actor: Nicholas Cage, Tommy Lee Jones, Sean Young

6. **DEAD CONNECTION**
 1994, USA
 Director: Nigel Dick
 Actor: Michael Madsen, Lisa Sinclair, Paul Leslie Disley

1. "-It's like they say, like father, like son.
 -Boy, I hope not. My mother said that my father
 was a cross-dressing Marine drill instructor."

2. "-Remember, kid, if you can't stand the heat, stay out of Miami.
 -What metaphor is that?
 -What metaphor? You ever been down there in August?
 Your balls stick to your leg like crazy glue."

3. "-You think everytime I look in the mirror I shout' gee,
 I'm glad I'm me and not some 20 year old billionaire rock star
 with the body of an athlete and a 24 hour erection! No, I don't!
 So just excuse the shit out of me!!"

4. "-Life's a bitch, then you die.
 -No, honey. You're the bitch.
 -Oh, so aggressive! It's turning me on!"

5. "-Two thousand francs?
 -I'm sorry, is the amount not adequate?
 -What, are you planning on bringing friends? Listen mister,
 maybe this is what hookers look like in Greece, but I'm no
 hooker, I'm a housewife. We do it for free!"

6. "-I'm Dick, you can call me... Dick."

 ANSWER >

1. **THE FORSAKEN**
 2001, USA
 Director: JS Cardone
 Actor: Kerr Smith, Brendan Fehr, Jonathan Schaech

2. **NORTH**
 1994, USA
 Director: Rob Reiner
 Actor: Elijah Wood, Bruce Willis, Jason Alexander

3. **THE REF**
 1994, USA
 Director: Ted Demme
 Actor: Denis Leary, Judy Davis, Kevin Spacey

4. **JAWBREAKER**
 1999, USA
 Director: Darren Stein
 Actor: Rose McGowan, Rebecca Gayheart, Julie Benz

5. **ONCE UPON A CRIME**
 1992, USA
 Director: Eugene Levy
 Actor: John Candy, James Belushi, Cybill Shepherd

6. **GHOULIES**
 1985, USA
 Director: William Friedkin
 Actor: Chevy Chase, Sigourney Weaver, Gregory Hines

1. "-Let me get this straight: you flew all the way down to Miami and kidnapped me from my hotel room in the middle of the night just because you couldn't get an erection?
-Don't that prove I'm motivated?
-You know, you can take a pill for that.
-Nah, you start with the pills, the next thing you know you're putting in hydraulics. A hard-on should be achieved legitimately or it shouldn't be achieved at all.
-Hmm, I think Mark Twain said that, didn't he?"

2. "-Are you a clone of an angel?
-Ohhh how sweet, but no I'm not.
-Are you sure you don't have a little clone in you?
-Yes I'm sure.
-Would you like to?"

3. "-We're very proud of you son. Don't forget your penis cream."

4. "-Me don't like you. You bad husband.
You have little ding-a-ling anyway."

5. "-I'm gettin' more ass than a toilet seat."

6. "-It will be a pleasure serving under you."

ANSWER >

1. **ANALYZE THIS**
 1999, USA
 Director: Harold Ramis
 Actor: Robert De Niro, Billy Crystal, Lisa Kudrow

2. **AUSTIN POWERS IN GOLDMEMBER**
 2002, USA
 Director: Jay Roach
 Actor: Mike Myers, Michael Caine, Beyonce Knowles

3. **AMERICAN PIE 2**
 2001, USA
 Director: JB Rogers
 Actor: Jason Biggs, Shannon Elizabeth, Alyson Hannigan

4. **THE ADVENTURES OF PRISCILLA,**
 1994, AUSTRALIA
 Director: Stephan Elliot
 Actor: Terence Stamp, Hugo Weaving, Guy Pearce

5. **THE DEER HUNTER**
 1978, USA
 Director: Michael Cimino
 Actor: Robert De Niro, John Cazale, John Savage

6. **YOU ONLY LIVE TWICE**
 1967, UNITED KINGDOM
 Director: Lewis Gilbert
 Actor: Sean Connery, Akiko Wakabayashi, Tetsuro Tamba

1. "-I didn't know you smoked.
 -Just after sex, Bob. I'm trying to give it up.
 -Well, at least you don't smoke that much.
 -About a pack a day.
 -That'll kill ya!
 -Bob, it won't kill ya. But it will make you very sore."

2. "-Just once I'd like to wear a sexy white dress blowing all around me and not have men run away screaming. Just once I'd like to have the kind of sexual experience where you don't have to go to the bathroom and cry afterwards.
 -I bet Marilyn cried in the bathroom after sex, probably more than once. Everyone does. Men too?
 -They can't. They're asleep."

3. "-What did the ghost say to the bee? Boobee."

4. "-We're VIP's.
 -Very immense penises."

5. "-I was married for four years, and pretended to be happy; and I had six years of analysis, and pretended to be sane. My husband ran off with his boyfriend, and I had an affair with my analyst, who told me I was the worst lay he'd ever had."

6. "-Get your hands off that steaming dog turd, It's mine."

1. **REAL MEN**
 1987, USA
 Director: Dennis Feldman
 Actor: James Belushi, John Ritter, Barbara Barrie

2. **CASUAL SEX**
 1988, USA
 Director: Genevieve Robert
 Actor: Lea Thompson, Victoria Jackson, Stephen Shellen

3. **DOGFIGHT**
 1991, USA
 Director: Nancy Savoca
 Actor: River Phoenix, Lili Taylor, Richard Panebianco

4. **REVENGE OF THE NERDS II: NERDS IN PARADISE**
 1987, USA
 Director: Joe Roth
 Actor: Robert Carradine, Curtis Armstrong, Larry B. Scott

5. **NETWORK**
 1976, USA
 Director: Sidney Lumet
 Actor: William Holden, Faye Dunaway, Peter Finch

6. **PINK FLAMINGOS**
 1972, USA
 Director: John Waters
 Actor: Divine, David Lochary, Mary Vivian Pearce

RATED: XXX

www.nicotext.com

1. "-Thomas can raise a barn, but can he pick up a 7-10 split?
 -God blessed my brother to be a good carpenter. It's okay.
 -Yeah, well he blessed you, too, and I'll give you a hint what
 it is. It's round, has three holes, and you put your fingers into it.
 -You leave Rebecca out of this!"

2. "-Give me an 'H'! Give me a 'U'! Give me a - giant pussy-licking,
 ass-fucker cock shit! I'm sorry. That was my Tourette's."

3. "-We're not going to some white collar resort prison. No, no, no!
 We're going to federal POUND ME IN THE ASS prison!"

4. "-Ashtray! You little bitch ass motherfucker!
 Come over here and give your grandma a hug!"

5. "-Hey, whatcha rent? "Best of Both Worlds"?
 -Hermaphroditic porn. Starlets with both organs. You should
 see the box. Beautiful chicks with dicks that put mine to shame.
 -And you rented this?
 -Hey, I like to expand my horizons."

6. "-Marriages don't break up on account of infidelity.
 It's just a symptom that something else is wrong.
 -Oh really? Well, that "symptom" is fucking my wife."

 ANSWER >

1. KINGPIN
 1996, USA
 Director: Peter Farrelly, Bobby Farrelly
 Actor: Woody Harrelson, Randy Quaid, Vanessa Angel

2. NOT ANOTHER TEEN MOVIE
 2001, USA
 Director: Joel Gallen
 Actor: Chyler Leigh, Chris Evans, Jaime Pressly

3. OFFICE SPACE
 1999, USA
 Director: Mike Judge
 Actor: Ron Livingston, Jennifer Aniston, David Herman

4. DON'T BE A MENACE TO SOUTH CENTRAL WHILE
 DRINKING YOUR JUICE IN THE HOOD
 1996, USA
 Director: Paris Barclay
 Actor: Shawn Wayans, Marlon Wayans, Tracey Cherelle Jones

5. CLERKS
 1994, USA
 Director: Kevin Smith
 Actor: Brian O'Halloran, Jeff Anderson, Marilyn Ghigliotti

6. WHEN HARRY MET SALLY
 1989, USA
 Director: Rob Reiner
 Actor: Billy Cristal, Meg Ryan, Carrie Fisher

www.nicotext.com

1. "-What do we do now, Nick?
 -Fuck like minxs, raise rugrats, live happily ever after.
 -Hate rugrats.
 -Fuck like minxs, forget rugrats, and live happily ever after."

2. "-Are you ready to order?
 -Yes, goddammit. I'm going to have the fucking poached salmon, with the son-of-a-bitching rice, and a dirty bastard salad with a shitload of Roquefort dressing. Thank you. And um, who knows what this asshole wants.
 -Uh, I'll just take a fucking beer."

3. "-Can I go now?
 -Yeah, sure.
 -Thanks, I'm exhausted, you know how it is.
 -Yeah, all dressed up and no one to blow."

4. "-Didn't you notice you were sitting on his face!
 -Well, it was a bit uncomfortable but I thought it was my hemorrhoids."

5. "-We're something, aren't we? The only animals that shove things up their ass for survival."

6. "-Fifty bucks, Grandpa. For seventy-five, the wife can watch."

ANSWER >

1. **BASIC INSTINCT**
 1992, USA
 Director: Paul Verhoeven
 Actor: Michael Douglas, Sharon Stone, George Dzundza

2. **DOGFIGHT**
 1991, USA
 Director: Nancy Savoca
 Actor: River Phoenix, Lili Taylor, Richard Panebianco

3. **LETHAL WEAPON**
 1987, USA
 Director: Richard Donner
 Actor: Mel Gibson, Danny Glover, Gary Busey

4. **MEET THE FEEBLES**
 1989, NEW ZEELAND
 Director: Peter Jackson
 Actor: Donna Akersten, Stuart devenie, Mark Hadlow

5. **PAPILLON**
 1973, USA
 Director: Franklin J Schaffner
 Actor: Steve McQueen, Dustin Hoffman, Victor Jory

6. **PRETTY WOMAN**
 1990, USA
 Director: Garry Marshall
 Actor: Richard Gere, Julia Roberts, Ralph Bellamy

www.nicotext.com

1. "-She was fifteen years old, going on thirty-five, Doc, and she told me she was eighteen, she was very willing, I practically had to take to sewing my pants shut. Between you and me, uh, she might have been fifteen, but when you get that little red beaver right up there in front of you, I don't think it's crazy at all and I don't think you do either. No man alive could resist that, and that's why I got into jail to begin with."

2. "-Yeah, he's a nice kid, pretty kid,
 don't know whether to fuck him or fight him."

3. "-And what classes are you taking...Dick?
 -Ummm, Gangbang 101, Freebase Tutorial,
 and Oral Sex Workshop."

4. "-Must be nice to fuck a lawyer, instead of being fucked by one."

5. "-I bet you're the kind of guy that would fuck a person in the ass and not even have the god damned common courtesy to give him a reach around."

6. "-Unfortunately, you don't have the balls to back up the actions of your huge cock."

ANSWER >

1. **ONE FLEW OVER THE CUCKOO'S NEST**
 1975, USA
 Director: Milos Forman
 Actor: Jack Nicholson, Louise Fletcher, Brad Dourif

2. **RAGING BULL**
 1980, USA
 Director: Martin Scorsese
 Actor: Robert De Niro, Cathy Moriarty, Joe Pesci

3. **THE RULES OF ATTRACTION**
 2002, USA
 Director: Roger Avary
 Actor: James Van Der Beek, Ian Somerhalder, Shannyn Sossamon

4. **RISING SUN**
 1993, USA
 Director: Philip Kaufmann
 Actor: Sean Connery, Wesley Snipes, Harvey Keitel

5. **FULL METAL JACKET**
 1987, UNITED KINGDOM
 Director: Stanley Kubrick
 Actor: Matthew Modine, Adam Baldwin, Vincent D'Onofrio

6. **FOUR ROOMS**
 1995, USA
 Director: Allison Anders, Alexandre Rockwell,
 Robert Rodriguez, Quenton Tarantino
 Actor: Tim Roth, Antonio Banderas, Jennifer Beals

www.nicotext.com

1. "-I didn't see any signs?
 -What do you call that?
 -Graffiti?
 -No no, it's not fucking graffiti, that's a sign.
 -You can't read it man.
 -I'll read it for you. It says this is fucking private property.
 No fucking trespassing. That means fucking you.
 -It says all that?
 -Yeah.
 -Well, if you maybe wrote in fucking English I would fucking
 understand you."

2. "-My God. I haven't been fucked like that since grade school."

3. "-We never see you anymore. What is it with you two? Still in
 your honeymoon? Too fucking busy, or too busy fucking?"

4. "-I'm not moving to Idaho. No fucking way.
 -Hey! That's a quarter in the swear jar, young lady.
 -Okay, there's no God damn way I'm God damn moving
 to Ida-son of a bitch, shit eating-ho."

5. "-You're like a life support system for a cock!"

6. "-You got to think about it like the first time you had sex.
 You gotta say, Daddy are you sure this is right?"

 ANSWER >

1. **FALLING DOWN**
 1993, USA
 Director: Joel Schumacher
 Actor: Michael Douglas, Robert Duvall, Barbara Hershey

2. **FIGHT CLUB**
 1999, USA
 Director: David Fincher
 Actor: Brad Pitt, Edward Norton, Helena Bonham Carter

3. **NORMAL LIFE**
 1996, USA
 Director: John McNaughton
 Actor: Ashley Judd Luke Perry Bruce A. Young

4. **MOVING**
 1988, USA
 Director: Alan Metter
 Actor: Richard Pryor, Beverly Todd, Stacey Dash

5. **THE DOOM GENERATION**
 1995, USA/FRANCE
 Director: Gregg Araki
 Actor: James Duval, Rose McGowan, Johnathon Schaech

6. **TANK GIRL**
 1995, USA
 Director: Rachel Talalay
 Actor: Lori Petty, Ice-T, Naomi Watts

1. "-How about if I wait six weeks to call. I could tell her I found
 her number while I was cleaning out my wallet, I can't remember
 where we met, I'll ask her what she looks like and then I'll ask
 her if we fucked. How about that? Would that be money?"

2. "-And the first thing that flashed into my gulliver was that I'd like
 to have her right down there on the floor with the old in-out,
 real savage."

3. "-Please give your most serious consideration to the bearer of this
 letter, Miss so-and-so, who is of moderate intelligence, who has
 some experience in broadcasting, and more importantly, who can
 suck your cock until your eyes pop out."

4. "-He said that he loved me.
 -Men say that. They all say that. Then they com."

5. "-I don't know why I pick the wrong men to fall in love with.
 My weakness is pretty boys with big sticks."

6. "-How come you always want to make love to me from behind?
 Is it because you want to pretend I'm somebody else?
 -Satan, your ass is gigantic and red. Who am I going to pretend
 you are, Liza Minelli?"

ANSWER >

1. **SWINGERS**
 1996, USA
 Director: Doug Liman
 Actor: Jon Favreau, Vince Vaughn, Ron Livingston

2. **A CLOCKWORK ORANGE**
 1971, USA
 Director: Stanley Kubrick
 Actor: Malcolm McDowell, Patrick Magee, Adrienne Corri

3. **TO DIE FOR**
 1995, USA
 Director: Gus Van Sant
 Actor: Nicole Kidman, Matt Dillon, Joaquin Phoenix

4. **PARENTHOOD**
 1989, USA
 Director: Ron Howard
 Actor: Steve Martin, Mary Steenburgen, Dianne Wiest

5. **WAITING TO EXHALE**
 1995, USA
 Director: Forest Whitaker
 Actor: Whitney Houston, Angela Bassett, Loretta Devine

6. **SOUTH PARK: BIGGER, LONGER & UNCUT**
 1999, USA
 Director: Trey Parker
 Actor: Trey Parker, Matt Stone, Mary Kay Bergman

1. "-You want subversion on a massive level. You know what one of the greatest fucking scripts ever written in the history of Hollywood is? Top Gun.
 -Oh, come on.
 -Top Gun is fucking great. What is Top Gun? You think it's a story about a bunch of fighter pilots.
 -It's about a bunch of guys waving their dicks around.
 -It is a story about a man's struggle with his own homosexuality. It is! That is what Top Gun is about, man. You've got Maverick, all right? He's on the edge, man. He's right on the fucking line, all right? And you've got Iceman, and all his crew. They're gay, they represent the gay man, all right? And they're saying, go, go the gay way, go the gay way. He could go both ways.
 -What about Kelly McGillis?
 -Kelly McGillis, she's heterosexuality. She's saying: no, no, no, no, no, no, go the normal way, play by the rules, go the normal way. They're saying no, go the gay way, be the gay way, go for the gay way, all right? That is what's going on throughout that whole movie... He goes to her house, all right? It looks like they're going to have sex, you know, they're just kind of sitting back, he's takin' a shower and every thing. They don't have sex. He gets on the motorcycle, drives away. She's like, "What the fuck, what the fuck is going on here?" Next scene, next scene you see her, she's in the elevator, she is dressed like a guy. She's got the cap on, she's got the aviator glasses, she's wearing the same jacket that the Iceman wears. She is, okay, this is how I gotta get this guy, this guy's going towards the gay way, I gotta bring him back, I gotta bring him back from the gay way, so I'll do that through subterfuge, I'm gonna dress like a man. All right? That is how she approaches it. Okay, now let me just ask you - I'm gonna digress for two seconds here. I met this girl Amy here, she's like floating around here and everything. Now, she just got divorced, right? All right, but the REAL ending of the movie is when they fight the MIGs at the end, all right? Because he has passed over into the gay way. They are this gay fighting fucking force, all right? And they're beating the Russians, the gays are beating the Russians. And it's over, and they fucking land, and Iceman's been trying to get Maverick the entire time, and finally, he's got him, all right? And what is the last fucking line that they have together? They're all hugging and kissing and happy with each other, and Ice comes up to Maverick, and he says, "Man, you can ride my tail, anytime!" And what does Maverick say? "You can ride mine!" Swordfight! Swordfight! Fuckin' A, man!"

ANSWER >

1. SLEEP WITH ME
 1994, USA
 Director: Rory Kelly
 Actor: Craig Sheffer, Eric Stoltz, Meg Tilly

1. "-I'm just tryin' to do to white girls what the white man's been doin' to us for 400 years.
-Yeah, what's that?
-Fuck 'em."

2. "-If you know so much, tell me something about myself.
-You masturbate more than anyone else on the planet.
-Shit, everyone knows that. Tell me something else.
-When you do it, you're thinking about guys.
-Dude, not ALL the time!"

3. "-You okay?
-No, I'm not okay! Do I look okay? The fucker shot me! What the fuck-ass fuck of a bum-fuck shithole town is this? I make a business call. I give him my card. And the hick-ass fucker shoots my foot off! Cock-fucking shit!"

4. "-Nothing disgusts me. At the age of eleven I walked in on my father and the Shetland pony. Does that excite you?
-I don't know, I never met your father."

5. "-"Fuck her brains out." It ranks right up there with that other classic: "bang the shit out of her."."

6. "-Look, it's my favorite cheese-eating dickmonkey."

ANSWER >

1. DON'T BE A MENACE TO SOUTH CENTRAL WHILE DRINKING YOUR JUICE IN THE HOOD
 1996, USA
 Director: Paris Barclay
 Actor: Shawn Wayans, Marlon Wayans, Tracey Cherelle Jones

2. DOGMA
 1999, USA
 Director: Kevin Smith
 Actor: Matt Damon, Ben Affleck, Linda Fiorentino

3. MYSTERY ALASKA
 1999, USA
 Director: Jay Roach
 Actor: Russell Crowe, Burt Reynolds, Hank Azaria

4. THE ADVENTURES OF FORD FAIRLANE
 1990, USA
 Director: Renny Harlin
 Actor: Andrew Dice Clay, Wayne Newton, Priscilla Presley

5. CITY SLICKERS
 1991, USA
 Director: Ron Underwood,
 Actor: Billy Crystal, Daniel Stern, Bruno Kirby

6. DRIVE
 1997, USA
 Director: Steve Wang
 Actor: Mark Dacascos, Kadeem Hardison, John Pyper-Ferguson

www.nicotext.com

1. "-The governor of Louisiana gave me this. Madame Tinkertoy's House of Blue Lights, corner of Bourbon and Toulouse, New Orleans, Louisiana. Now, this is supposed to be the finest whorehouse in the south. These ain't no pork chops! These are U.S. PRIME!"

2. "-I do love you and you know there is something very important we need to do as soon as possible.
 -What's that?
 -Fuck."

3. "-That's it He didn't say stick with Mrs. Crock and you'll get ahead, he said stick Mrs. Crock and you'll get head."

4. "-Have you thought of a name for it yet?
 -I was thinking along the lines of...Dick does Daisy.
 -No. That's lousy.
 -How about...Anal Antics?
 -Anal Antics...yes. It will appeal to the intellectuals. Do you think it will do as well as our last release and win the hooker prize?"

5. "-Just look inside yourself and you'll see me waving up at you naked wearing only a cock ring."

6. "-Right now I'd go down on a lawman for a gallon of gas."

ANSWER >

1. EASY RIDER
 1969, USA
 Director: Dennis Hopper
 Actor: Dennis Hopper, Peter Fonda, Jack Nicholson

2. EYES WIDE SHUT
 1999, USA
 Director: Stanley Kubrick
 Actor: Tom Cruise, Nicole Kidman, Sydney Pollack

3. SCREWED
 2000, USA
 Director: Rod Fontana
 Actor: Temptress, Tori Teeze, Nina Whett

4. MEET THE FEEBLES
 1989, NEW ZEELAND
 Director: Peter Jackson
 Actor: Donna Akersten, Stuart devenie, Mark Hadlow

5. PUMP UP THE VOLUME
 1990, USA
 Director: Allan Moyle
 Actor: Christian Slater, Ellen Greene, Annie Ross

6. NATURAL BORN KILLERS
 1994, USA
 Director: Oliver Stone
 Actor: Woody Harrelson, Juliette Lewis, Robert Downey Jr.

1. "-I had this dream...
 -Do we have to do dreams?
 -I'm in this restaurant, and the waiter brings me my entree.
 It was a salad. It was Lloyd's head on a plate of spinach with his
 penis sticking out of his ear. And I said, "I didn't order this." And
 the waiter said, "Oh you must try it, it's a delicacy. But don't eat
 the penis, it's just garnish."
 -Lloyd, what do you think about the dream?
 -I think she should stop telling it at dinner parties to all
 our friends."

2. "-Oh, I think she's saying, "Stick it in me twice a day, and I'll do
 anything for you. I'll lick the ground you walk on.".""

3. "-What's the weirdest sex thing you ever did? Did you ever fuck
 two women at once?
 -Yeah, your mother and your father."

4. "-I got a feeling that behind those jeans is something wonderful
 just waiting to get out."

5. "-Lesbian Nazi Hookers Abducted by UFOs and Forced Into
 Weight Loss Programs...All next week on Town Talk!"

6. "-Just what this country needs: a cock in a frock on a rock."

ANSWER >

1. **THE REF**
 1994, USA
 Director: Ted Demme
 Actor: Denis Leary, Judy Davis, Kevin Spacey

2. **POINT OF NO RETURN**
 1993, USA
 Director: John Badham
 Actor: Bridget Fonda, Gabriel Byrne, Dermot Mulroney

3. **DEEP COVER**
 1992, USA
 Director: Bill Duke
 Actor: Larry Fishburne, Jeff Goldblum, Victoria Dillard

4. **BOOGIE NIGHTS**
 1997, USA
 Director: Paul Thomas Anderson
 Actor: Mark Wahlberg, Burt Reynolds, Julianne Moore

5. **UHF**
 1989, USA
 Director: Jay Levey
 Actor: Weird Al' Yankovic, Victoria Jackson, Kevin McCarthy

6. **THE ADVENTURES OF PRISCILLA, QUEEN OF THE DESERT**
 1994, AUSTRALIA
 Director: Stephan Elliot
 Actor: Terence Stamp, Hugo Weaving, Guy Pearce

www.nicotext.com

1. "-Brodie, I've always taken you with a grain of salt. On your birthday, when you told me to do a striptease to the theme of "Mighty Mouse," I did it. On prom night at the hotel when you told me to sleep under the bed in case your mother barged in, I said okay. And even during my grandmother's funeral when you told my relatives that you could see her nipples through her burial dress, I let that slide. But if you think I'm gonna suffer any of your shit with a smile now that we're broken up, you're in for some serious fucking disappointment!"

2. "-I don't even know what to call you.
 -BROKE dick seems to be popular."

3. "-It's not cheating if you spread peanut butter on your balls and let your dog lick it off...cause it's YOUR dog, get it?"

4. "-If you're so hot on the idea, why don't you have sex with him?
 -Taste of semen makes me gag.
 -How would you know? Whose semen were you eating?
 -My own."

5. "-I like simple pleasures, like butter in my ass, lollipops in my mouth. That's just me. That's just something that I enjoy."

6. "-No, but I ah Heard Mr. Murphy, you know the shop teacher? Got his Dick caught in a vacuum cleaner."

ANSWER >

1. **MALLRATS**
 1995, USA
 Director: Kevin Smith
 Actor: Shannen Doherty, Jeremy London, Jason Lee

2. **THE NEW GUY**
 2002, USA
 Director: Ed Decter
 Actor: DJ Qualls, Eliza Dushku, Zooey Deschane

3. **ROAD TRIP**
 2000, USA
 Director: Todd Phillips
 Actor: Breckin Meyer, Seann William Scott, Amy Smart

4. **THREESOME**
 1994, USA
 Director: Andrew Fleming
 Actor: Lara Flynn Boyle, Stephen Baldwin, Josh Charles

5. **BOOGIE NIGHTS**
 1997, USA
 Director: Paul Thomas Anderson
 Actor: Mark Wahlberg, Burt Reynolds, Julianne Moore

6. **TEEN WOLF**
 1985, USA
 Director: Rod Daniel
 Actor: Michael J Fox, James Hampton, Scott Paulin

www.nicotext.com

1. "-How come you guys always make that noise?
 -What noise?
 -This one.
 -I mean you guys spit so much, it kind of makes you wonder
 what you've be sucking on."

2. "-Goddamn it, I knew I should've listened to my mother. I could've
 been a cosmic surgeon, five hundred thou a year, up to my neck
 in tits and ass."

3. "-What's the difference between a hooker and a lawyer?
 A hooker will stop screwing you when you die...most people
 don't chose this as a profession, can't take all the insult."

4. "-Go fuck yourself, Kelvin.
 -I frequently do! And I fucking enjoy it!"

5. "-What is a "proper relationship"?
 -Living with someone who talks to you after they banged you."

6. "-Hey, would you like to come over after I get off work and do me
 doggie style?
 -Aaa, no thanks. By the way, wha'd ya do to me last night?
 I can barely walk.
 -No pain, no gain."

ANSWER >

1. **EIGHT DAYS A WEEK**
 1999, USA
 Director: Michael Davis
 Actor: Joshua Schaefer, Keri Russell, R.D. Robb

2. **ROMANCING A STONE**
 1984, USA
 Director: Robert Zemeckis
 Actor: Kathleen Turner, Michael Douglas, Danny DeVito

3. **THE RAINMAKER**
 1997, USA
 Director: Francis Ford Coppola
 Actor: Matt Damon, Danny DeVito, Claire Danes

4. **LIKE IT IS**
 1998, UNITED KINGDOM
 Director: Paul Oremland
 Actor: Steve Bell, Ian Rose, Roger Daltrey

5. **NAKED**
 1993, UNITED KINGDOM
 Director: Mike Leigh
 Actor: David Thewlis, Lesley Sharp, Katrin Cartlidge

6. **HOLD ME, THRILL ME, KISS ME**
 1993, USA
 Director: Joel Hershman
 Actor: Max Parrish, Adrienne Shelly, Sean Young

1. "-Attention pussy shoppers! Take advantage of our penny pussy sale! If you buy one piece of pussy at the regular price, you get another piece of pussy of equal or lesser value for only a penny! Try and beat pussy for a penny! If you can find cheaper pussy anywhere, fuck it!"

2. "-So Izzy...how do you keep your voice is such fine shape?
 -Well, my choir teacher gave me a lot of lessons...
 -He eats a lot of pussy.
 -Oh yeah, I eat a lot of pussy...tons..."

3. "-Bunch of slack-jawed faggots around here! This stuff will make you a god damnned sexual Tyrannosaurus, just like me!"

4. "-What are you doin' here? You oughta be out in a convertible bird-doggin' chicks and bangin' beaver."

5. "-If a man builds a thousand bridges and sucks one dick, they don't call him a bridge-builder... they call him a cocksucker."

6. "-If you're gonna be a loser, raise your hand. IF you're gonna act like a pussy, raise your hand.
 -What the hell are you doing, J?
 -Well, I didn't want you to be the only pussy with your hand up, so I thought I'd help you out."

ANSWER >

1. **FROM DUSK TILL DAWN**
 1996, USA
 Director: Robert Rodriguez
 Actor: Harvey Keitel, George Clooney, Quentin Tarantino

2. **ROCK STAR**
 2001, USA
 Director: Stephen Herek
 Actor: Mark Wahlberg, Jennifer Aniston, Jason Flemyng

3. **PREDATOR**
 1987, USA
 Director: John McTiernan
 Actor: Arnold Schwarzenegger, Carl Weathers, Elpidia Carillo

4. **ONE FLEW OVER THE CUCKOO'S NEST**
 1975, USA
 Director: Milos Forman
 Actor: Jack Nicholson, Louise Fletcher, Brad Dourif

5. **PLAY IT TO THE BONE**
 1999, USA
 Director: Ron Shelton
 Actor: Woody Harrelson, Antonia Banderas, Lolita Davidovich

6. **ANY GIVEN SUNDAY**
 1999, USA
 Director: Oliver Stone
 Actor: Al Pacino, Cameron Diaz, Dennis Quaid

www.nicotext.com

1. "-They FUCK YOU at the drive-thru, okay? They FUCK YOU at the drive-thru! They know you're gonna be miles away before you find out you got fucked! They know you're not gonna turn around and go back, they don't care. So who gets fucked? Ol' Leo Getz! Okay, sure! I don't give a fuck! I'm not eating this tuna, okay?"

2. "-Ma'am, your husband Bernie, you didn't by any chance lead him to the lake blindfolded?
-If I had a dick, this is where I'd tell you to suck it!"

3. "-O.k, let me tell you what Like a virgin's about. It's all about this cooze who's a regular fuck machine, I'm talking morning, day, night, afternoon, dick, dick, dick, dick, dick, dick, dick, dick, dick.
-How many dicks is that?
-A lot."

4. "-Thanks a lot you shit-brained, fuck-faced, ball breaking, duck fucking pain in the ass.
-John Spartan, you are fined five credits for repeated violations of the verbal morality statute."

5. "-Don't say penis in this house!
-Penis! Penis! Big fucking erect penis, ma!"

6. "-Natalie, stay away, it's the dick of death!"

ANSWER >

1. **LETHAL WEAPON 2**
 1989, USA
 Director: Richard Donner
 Actor: Mel Gibson, Danny Glover, Joe Pesci

2. **LAKE PLACID**
 1999, USA
 Director: Steve Miner
 Actor: Bill Pullman, Bridget Fonda, Oliver Platt

3. **RESERVOIR DOGS**
 1992, USA
 Director: Quentin Tarantino
 Actor: Harvey Keitel, Tim Roth, Michael Madsen

4. **DEMOLITION MAN**
 1993, USA
 Director: Marco Brambilla
 Actor: Sylvester Stallone, Wesley Snipes, Sandra Bullock

5. **BORN ON THE FOURTH OF JULY**
 1989, USA
 Director: Oliver Stone
 Actor: Tom Cruise, Willem Dafoe, Raymond J Barry

6. **TOMCATS**
 2001, USA
 Director: Gregory Poirier
 Actor: Jerry O'Connell, Shannon Elizabeth, Jake Busey

www.nicotext.com

1. "-The way your dad looked at it, this watch was your birthright. He'd be damned if any of the slopes were gonna get their greasy yellow hands on his boy's birthright. So he hid it in the one place he knew he could hide something: his ass. Five long years, he wore this watch up his ass. Then when he died of dysentery, he gave me the watch. I hid this uncomfortable piece of metal up my ass for two years. Then, after seven years, I was sent home to my family. And now, little man, I give the watch to you."

2. "-So what brings you to this part of town?
 -I'm a guidance counsellor at Blue Bay high school, a student there is accusing me of rape.
 -Male or female."

3. "-Do you know what happens if you do another turn in the joint.
 -Uh, fuck your father in the shower and then have a snack."

4. "-I wrote this musical called "Hello, Doctor, it's Still Swollen." It had a great opening, went like this: "Hello Mr. Colon, my prostate's feelin' swollen. I think that things are flowin' not so well."

5. "-Do you know what the Bible says about fucking your own sister? Don't!"

6. "-Virgins, I love 'em! No skank, no disease, just pure pussy!"

ANSWER >

1. PULP FICTION
 1994, USA
 Director: Quentin Tarantino
 Actor: John Travolta, Samuel L Jackson, Uma Thurman

2. WILD THINGS
 1998, USA
 Director: John McNaughton
 Actor: Kevin Bacon, Matt Dillon, Neve Campbell

3. THE USUAL SUSPECTS
 1995, USA
 Director: Bryan Singer
 Actor: Stephen Baldwin, Gabriel Byrne, Chazz PalMinteri

4. FATHERS' DAY
 1997, USA
 Director: Ivan Reitman
 Actor: Robin Williams, Billy Crystal, Julia Louis Dreyfus

5. SAY IT ISN'T SO
 2001, USA
 Director: James B Rogers
 Actor: Heather Graham, Chris Klein, Orlando Jones

6. KIDS
 1995, USA
 Director: Larry Clark
 Actor: Leo Fitzpatrick, Justin Pierce, Chloe Sevigny

1. "-When a man gets a hard on, you know where the blood come from, right? You know where the blood come from, right?
His head and his feet. So A - he's stupid and B - he can't run."

2. "-Fucking Denise. Denise the piece. Oh, you're gonna give me that cherry pie sweet mama baby!"

3. "-Well, the man don't just have to die, Foley. I mean, he could accidentally hurt himself falling down on something real hard, you know? Like a shiv, or my dick?"

4. "-Oh, Bernie, cut it out with the smoke. You know the doctor found nicotine in my urine again?
-Then stop stickin' your dick in my ashtray."

5. "-My job requires mostly masking my contempt for the assholes in charge, and, at least once a day, retiring to the men's room so I can jerk off while I fantasize about a life that less closely resembles Hell."

6. "-Seven decapitations in one week. Don't you just hate someone who only takes head and never gives it?
-You're bad, Matilda. Real bad."

 ANSWER >

1. **LOVE JONES**
 1997, USA
 Director: Theodore Witcher
 Actor: Larenz Tate, Nia long, Isaiah Washington

2. **MAGNOLIA**
 1999, USA
 Director: Paul Thomas Anderson
 Actor: Tom Cruise, Julianne Moore, John C Reilly

3. **OUT OF SIGHT**
 1998, USA
 Director: Steven Soderbergh
 Actor: George Clooney, Jennifer Lopez, Ving Rhames

4. **THE PAPER**
 1994, USA
 Director: Ron Howard
 Actor: Michael Keaton, Robert Duvall, Glenn Close

5. **AMERICAN BEAUTY**
 1999, USA
 Director: Sam Mendes
 Actor: Kevin Spacey, Annette Bening, Thora Birch

6. **THE RELIC**
 1997, USA/GERMANY/UNITED KINGDOM
 Director: Peter Hyams
 Actor: Penelope Ann Miller, Tom Sizemore, Linda Hunt

www.nicotext.com

1. "-I uh... I like your tight body. It looks like it would do what I tell it.
-What?
-I said...
-No, I heard what you said. And I'll admit 'What?' was a rather banal, cliché, noncolorful response. What I really meant to say was: 'Why don't you do the world a big fat fucking favor and crawl back into your mother's womb?'"

2. "-Y'all ain't shit. Your mama's ain't shit and your babies ain't gonna be shit. Fuck you with a... a sick dick."

3. "-Talk dirty to me baby.
-Ok I'm gonna work this, oh yeah, I'm gonna piss in your face and fart in yo' mouth and shit all over these walls Ray!
-Wait.
-Oops, too dirty?"

4. "-Once we get to Hollywood and find those Miramax fucks who are making that movie, we're gonna make 'em eat our shit, then shit out our shit, then eat their shit which is made up of our shit that we made 'em eat. Then you're all fucking next."

5. "-BELONG? That's a very sexist way to talk about these bitches!"

6. "-What are you, a fuckin' lawyer?
-Depends on who I'm with."

 ANSWER >

1. PLAYING BY HEART
 1998, USA
 Director: Willard Carroll
 Actor: Sean Connery, Gena Rowland, Gillian Anderson

2. THE PLAYERS CLUB
 1998, USA
 Director: Ice Cube
 Actor: LisaRaye, Monica Calhoun, Bernie Mac

3. SCARY MOVIE II
 2001, USA
 Director: Keenen Ivory Wayans
 Actor: Shawn Wayans, Marlon Wayans, Anna Faris

4. JAY AND SILENT BOB STRIKE BACK
 2001, USA
 Director: Kevin Smith
 Actor: Jason Mewes, Kevin Smith, Ben Affleck

5. ALI G INDAHOUSE
 2002, UNITED KINGDOM
 Director: Mark Mylod
 Actor: Sacha Baron Cohen, Michael Gambon, Charles Dance

6. OTHER PEOPLE'S MONEY
 1991, USA
 Director: Norman Jewison
 Actor: Danny Devito, Gregory Peck, Penelope Ann Miller

1. "-Your responsibility is to be a dickhead. And how hard can that be? All you have to do is make sure your head is a dick and it's attached to your head."

2. "-You play with your balls alot.
-Oh really?
-Yeah, you do more ballhandling in one minute than Larry Bird does in an hour.
-You know what I'd really like?
-A couple of more hands and an extra set of balls?."

3. "-I don't like your jerk-off name, I don't like your jerk-off face, I don't like your jerk-off behavior, and I don't like you, Jerk-Off.
-Do I make myself clear?
-I'm sorry I wasn't listening."

4. "-Would the following students please report to the Principal's office: Jack Mehoff, Mike Hunt, Lou Zer, and Heywood Jablomee."

5. "-Do you know how many poor animals they had to kill to make that coat?
-Know how many rich animals I had to fuck to get this coat?"

6. "-And what would you like Mr Karew?
-I suppose a fuck is out of the question."

ANSWER >

1. **PATCH ADAMS**
 1998, USA
 Director: Tom Shadyac
 Actor: Robin Williams, Daniel London, Monica Potter

2. **PLANES, TRAINS & AUTOMOBILES**
 1987, USA
 Director: John Hughes
 Actor: Steve Martin, John Candy, Laila Robins

3. **THE BIG LEBOWSKI**
 1998, USA
 Director: Joel Coen
 Actor: Jeff Bridges, John Goodman, Julianne Moore

4. **SHRIEK IF YOU KNOW WHAT I DID LAST FRIDAY THE THIRTEENTH**
 2000, USA
 Director: John Blanchard
 Actor: Julie Benz, Harley Cross, Majandra Delfino

5. **SWITCH**
 1991, USA
 Director: Blake Edwards
 Actor: Ellen Barkin, Jimmy Smits, JoBeth Williams

6. **SEE NO EVIL, HEAR NO EVIL**
 1989, USA
 Director: Arthur Hiller
 Actor: Richard Pryor, Gene Wilder, Joan Severance

1. "-Woman! What could I say? Who made them? God must be a fucking genius. They say hair is everything. Have you ever buried your nose in a mountain of curls, just wanted to go to sleep forever? Or lips, and when they touched yours were like the first swallow of a wine after you just cross the desert. Tits! Hoo-ahh! Big ones, little ones, nipples staring right out at you like secret searchlights. Legs. I don't care if they're Greek columns or second-hand Steinways, what's between'em, Passport to heaven. I need a drink. Yes Mr. Sims, there's only two syllables in this world worth hearing...pussy."

2. "-Where's your wife?
 -Uh, I dunno. Probably out fucking that dorky, prince-of-real-estate asshole."

3. "-You want justice, go to a whorehouse. You wanna get fucked, go to court."

4. "-I wouldn't suck your lousy dick if I was suffocating and there was oxygen in your balls!"

5. "-One Timex digital watch, broken. One unused prophylactic. One soiled."

6. "-This stuff's nuttier than my shit after I've eaten an Almond Roca!"

ANSWER >

1. **SCENT OF A WOMAN**
 1992, USA
 Director: Martin Brest
 Actor: Al Pacino, Chris O'Donnell, James Rebhorn

2. **AMERICAN BEAUTY**
 1999, USA
 Director: Sam Mendes
 Actor: Kevin Spacey, Annette Bening, Thora Birch

3. **PRIMAL FEAR**
 1996, USA
 Director: Gregory Hoblit
 Actor: Richard Gere, Edward Norton, Laura Linney

4. **FEMALE TROUBLE**
 1974, USA
 Director: John Waters
 Actor: Divine, Bob Adams, Sally Albaugh

5. **THE BLUES BROTHERS**
 1980, USA
 Director: John Landis
 Actor: John Belushi, Dan Aykroyd, Cab Calloway

6. **NURSE BETTY**
 2000, USA
 Director: Neil LaBute
 Actor: Morgan Freeman, Renee Zellweger, Chris Rock

1. "-High school is a lot like prison: Bad food, high fences; the sex
 you want, you ain't gettin', the sex you gettin', you don't want.
 I've seen terrible things.
 -Yesterday, an eighty-year-old librarian broke my penis.
 -You win."

2. "-You pompous, stuck-up, snot-nosed, English, giant, twerp,
 scumbag, fuck-face, dickhead, asshole.
 -How very interesting. You're a true vulgarian, aren't you?
 -You are the vulgarian, you fuck!"

3. "-Oh me and my wife had a great sex life, we use to have sex
 once a week. but then she died... Then it was 3 or 4 times
 a week!"

4. "-This check seems to be made out to "selfish,
 arrogant dickhead."
 -Yeah, they'll cash it. They know it's you."

5. "-What's the difference between a wife and a job?
 After 10 years a job still sucks."

6. "-Don't look now but we're about to get fubar'ed.
 -What the hell is fubar.
 -Fucked up beyond all recognition."

ANSWER >

1. THE NEW GUY
 2002, USA
 Director: Ed Decter
 Actor: DJ Qualls, Eliza Dushku, Zooey Deschane

2. A FISH CALLED WANDA
 1988, UNITED KINGDOM
 Director: Charles Crichton
 Actor: John Cleese, Jamie Lee Curtis, Kevin Kline

3. SAY IT ISN'T SO
 2001, USA
 Director: James B Rogers
 Actor: Heather Graham, Chris Klein, Orlando Jones

4. THE THING CALLED LOVE
 1993, USA
 Director: Peter Bogdanovich
 Actor: River Phoenix, Samantha Mtahis, Dermot Mulroney

5. WHAT WOMAN WANT
 2000, USA
 Director: Nancy Meyers
 Actor: Mel Gibson, Helen Hunt, Marisa Tomei

6. TANGO & CASH
 1989, USA
 Director: Andrei Konchalovsky
 Actor: Sylvester Stallone, Kurt Russell, Teri Hatcher

1. "-Millions of years of evolution, right? Right? Men have to stick it in every place they can, but for women... women it is just about security and commitment and whatever the fuck else!
 -A little oversimplified, Alice, but yes, something like that.
 -If you men only knew..."

2. "-I jerked of to your secretary last night, I hope you don't mind.
 -Why should I mind.
 -I don't know, I just wanted to make sure it was alright, so I could forge ahead with a clear conscience.
 -Pound away."

3. "-To me, marriage is a sacred institution. So tell me, you and the wife do it doggie-style, or what?"

4. "-You are such a fuckass!
 -Did you just call me a fuckass?! You can go suck a fuck!
 -Oh, please, tell me Elizabeth, how exactly does one suck a fuck?!"

5. "-Respect the cock... and tame the cunt! Tame it!"

6. "-He's a natural, ain't you Tyrone?
 -'course I am...
 -A natural fucking idiot."

 ANSWER >

1. **EYES WIDE SHUT**
 1999, USA
 Director: Stanley Kubrick
 Actor: Tom Cruise, Nicole Kidman, Sydney Pollack

2. **THE STORY OF US**
 1999, USA
 Director: Rob Reiner
 Actor: Bruce Willis, Michelle Pfeiffer, Tim Matheson

3. **POLICE ACADEMY**
 1984, USA
 Director: Hugh Wilson
 Actor: Steve Guttenberg, GW Bailey, George Caynes

4. **DONNIE DARKO**
 2001, USA
 Director: Richard Kelly
 Actor: Jake Gyllenhaal, Holmes Osborne, Maggie Gyllenhaal

5. **MAGNOLIA**
 1999, USA
 Director: Paul Thomas Anderson
 Actor: Tom Cruise, Julianne Moore, John C Reilly

6. **SNATCH**
 2000, UNITED KINGDOM
 Director: Guy Ritchie
 Actor: Benicio Del Toro, Dennis Farina, Vinnie Jones

1. "-Holy shit dude! I found a dildo! Dildo! Dildo! Dildo! Big blue rubber dicks for everyone! The people demand rubber dicks!"

2. "-Playing to lose is like sleeping with your sister. Sure she's a great piece of tail with a blouse full of goodies, but it's just illegal. Then you get into that whole inbred thing. Kids with no teeth who do nothing but play the banjo... eat apple sauce through a straw... pork farm animals."

3. "-They can suck my pathetic little dick, and I'll dip my balls in marinara sauce so those fat bastards can get a taste of home while they're at it!"

4. "-You ever come back here we'll tie you to a tree, fuck you in the ass while we jerk you off and show you what we really do to perverts."

5. "-Ah. Had a little frat boy protein shake, did ya?
-I feel so sick. I mean, I can feel them swimming inside me. Should I get my stomach pumped or something?
-Felicia, the only thing you need to get pumped is the air out of your head."

6. "-Floyd be saying he don't eat pussy.
-Shit any nigga saying he don't eat pussy is lying his ass off."

 ANSWER >

1. **AMERICAN PIE 2**
 2001, USA
 Director: JB Rogers
 Actor: Jason Biggs, Shannon Elizabeth, Alyson Hannigan

2. **HOT SHOTS!**
 1991, USA
 Director: Jim Abrahams
 Actor: Charlie Sheen, Cary Elwas, Valeria Golino

3. **THE BOONDOCKSAINTS**
 1999, USA/CANADA
 Director: Troy Duffy
 Actor: Willem Dafoe, Sean Patrick Flanery, Norman Reedus

4. **SAY IT ISN'T SO**
 2001, USA
 Director: James B Rogers
 Actor: Heather Graham, Chris Klein, Orlando Jones

5. **URBAN LEGEND**
 1998, USA
 Director: Jamie Blank
 Actor: Jared Leto, Alicia Witt, Rebecca Gayheart

6. **TRUE ROMANCE**
 1993, USA
 Director: Tony Scott
 Actor: Christian Slater, Patricia Arquette, Dennis Hopper

 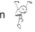

1. "-OK...not! Fuck, shit, cock, ass, titties, boner, bitch, muff, pussy, cunt, butthole, Barbra Streisand!"

2. "-Page 108, paragraph 3, No jokes involving flatulence, excretion, urination, ejaculation, or other bodily functions.
 -Also, no use of the seven so-called seven dirty words. These are cocksucker, mother fucker, shit, cunt, cock, and pussy."

3. "-Does the president think of fucking every woman he meets? Oh sorry, bad example."

4. "-Holy hell, is that monkey waving at us? Oh shit! It understood us! Maybe it's some kind of super monkey. What if there's more supermonkeys up at that lab? WHAT IF THEY'RE CREATING AN ARMY OF THEM? Holy shit! It must be a conspiracy like in the X-Files....ROSWELL style! This little monkey could be the fuckin' damn dirty ape responsible for the fall of the human race. In this world gone mad, we won't spank the monkey- the monkey will spank us."

5. "-Katy, I try to give you everything I can give.
 -Oh, you give all right - presents, clothes. I just wish you weren't so generous with your cock."

6. "-You stick your dick in my mouth and NOW you get an attack of morality?"

 ANSWER >

1. **SOUTH PARK: BIGGER, LONGER & UNCUT**
 1999, USA
 Director: Trey Parker
 Voices: Trey Parker, Matt Stone, Mary Kay Bergman

2. **PRIVATE PARTS**
 1997, USA
 Director: Betty Thomas
 Actor: Howard Stern, Robin Quivers, Mary McCormack

3. **DECONSTRUCTING HARRY**
 1997, USA
 Director: Woody Allen
 Actor: Woody Allen, Richard Benjamin, Kirstie Alley

4. **JAY AND SILENT BOB STRIKE BACK**
 2001, USA
 Director: Kevin Smith
 Actor: Jason Mewes, Kevin Smith, Ben Affleck

5. **ALL THAT JAZZ**
 1979, USA
 Director: Bob Fosse
 Actor: Roy Schneider, Jessica Lange, Ann Reinking

6. **DISCLOSURE**
 1994, USA
 Director: Barry Levinson
 Actor: Michael Douglas, Demi Moore, Donald Sutherland

1. "-Is there more to it?
 -Just this room.
 -And a bedroom?
 -No bedroom.
 -Where does he sleep?
 -Who said he sleeps?
 -Well, where does he fuck?
 -Everywhere!"

2. "-You're all I thought about for six months. They threw me in a jail
 filled with rejects from the communicable disease ward. Every
 wacko, drippy, open-sored low-life was in that joint, all of them
 wanting to hire on as my proctologist."

3. "-So what do ya think, Cordell? Does Lecter want to fuck
 her or kill her or eat her alive?
 -Probably all three, though I wouldn't want to predict in
 what order."

4. "-All I did was I parked the car on a nice lonely road,
 I looked at her, and I said "fuck or fight.".."

5. "-There is something wrong with your cow. I reach under there
 and I'm pulling, tugging, tugging, pulling, nothing, not a drop.
 -The cow's name is Norman. You were pulling on his dick.
 -I'm gonna go wash up."

1. THE DEVIL'S ADVOCATE
 1997, USA
 Director: Taylor Hackford
 Actor: Al Pacino, Keanu Reeves, Charlize Theron

2. THE JEWEL OF THE NILE
 1985, USA
 Director: Lewis Teague
 Actor: Michael Douglas, Kathleen Turner, Danny DeVito

3. HANNIBAL
 2001, USA
 Director: Ridley Scott
 Actor: Anthony Hopkins, Julianne Moore, Ray Liotta

4. DINER
 1982, USA
 Director: Barry Levinson
 Actor: Steve Guttenberg, Daniel Stern, Mickey Rourke

5. CITY SLICKERS II: THE LEGEND OF CURLY'S GOLD
 1994, USA
 Director: Paul Weiland
 Actor: Billy Crystal, Daniel Stern, Jon Lovitz

1. "-Fucking... What the fucking fuck! Who the fuck fucked this fucking... How did you two fucking fucks... FUCK!
 -Well it... certainly illustrates the diversity of the word."

2. "-Hey, sewer rat may taste like pumpkin pie but I'd never know 'cause I wouldn't eat the filthy motherfuckers. Pigs sleep and root in shit. That's a filthy animal. I ain't eat nothin' that ain't got enough sense to disregard its own faeces."

3. "-Horses are fascinating animals. Dumb as fenceposts but very intuitive. In that way they're not too different from high school girls: they may not have a brain in their head but they do know all the boys want to fuck 'em."

4. "-Goddess Diana, fail you I will. - I was to bring you fresh sperm from my Bill. - I had him erect and his semen would follow. - Alas, I was hot. So hot that I swallowed."

5. "-This tells us how much radiation we're getting?
 -Whoa! Whoa! Whoa! I ain't going in no radiation! No way!
 -Aw Hippy, you pussy.
 -Well what good is the money? Six months later, your dick drops off."

6. "-Do you know how I spend my every single solitary moment?
 -Jerking off?
 -No, that's a good guess though!"

ANSWER >

1. **THE BOONDOCKSAINTS**
 1999, USA/CANADA
 Director: Troy Duffy
 Actor: Willem Dafoe, Sean Patrick Flanery, Norman Reedus

2. **PULP FICTION**
 1994, USA
 Director: Quentin Tarantino
 Actor: John Travolta, Samuel L Jackson, Uma Thurman

3. **GRIMSON TIDE-DANGER RUNS DEEP**
 1995, USA
 Director: Tony Scott
 Actor: Denzel Washington, Gene Hackman, Matt Craven

4. **FOUR ROOMS**
 1995, USA
 Director: Allison Anders, Alexandre Rockwell,
 Robert Rodriguez, Quenton Tarantino
 Actor: Tim Roth, Antonio Banderas, Jennifer Beals

5. **THE ABYSS**
 1989, USA
 Director: James Cameron
 Actor: Ed Harris, Mary Elisabeth Mastrantonio, Michael Biehn

6. **MUMFORD**
 1999, USA
 Director: Lawrence Kasdan
 Actor: Loren Dean, Hope Davis, Jason Lee

1. "-Wrong place, wrong time. Nothing personal.
 -That's what you think. Last night I fucked your wife.
 -Oh you did, hah? How'd you know it was my wife?
 -She said her husband was a big pimp lookin'
 motherfucker with a hat.
 -Oh, you're real cool but you've got to take a bullet.
 -After fucking your wife I'll take two."

2. "-So, just listen. Now, did I or did I not... do... vaginal... juices?
 -Mmm. Mmm. Yes, sir. Yes, sir.
 -Name two ways of getting them flowing, Watson.
 -R-- rubbing the clitoris, sir?
 -What's wrong with a kiss, boy? Hmm? Why not start her off with
 a nice kiss? You don't have to go leaping straight for the clitoris
 like a bull at a gate. Give her a kiss, boy."

3. "-You haven't slept with her, have you?
 -That is a cheap question and the answer is, of course,
 no comment.
 -"No comment" means "yes."
 -No it doesn't.
 -Do you ever masturbate?
 -DEFINITELY no comment.
 -You see? It means "yes."."

4. "-What do you think would happen if I got him a professional...
 you know...
 -A professional?
 -Hooker. You know, the kind that can teach things... first-timers,
 you know... break him in.
 -But Joe, he's 11.
 -You're right, you're right. It's too late."

ANSWER >

1. **THE LAST BOYSCOUT**
1991, USA
Director: Tony Scott
Actor: Bruce Willis, Damon Wayans, Chelsea Field

2. **MONTY PYTHON'S THE MEANING OF LIFE**
1983, UNITED KINGDOM
Director: Terry Jones
Actor: Graham Chapman, John Cleese, Terry Gilliam

3. **NOTTING HILL**
1999, UNITED KINGDOM
Director: Roger Michell
Actor: Hugh Grant, Julia Roberts, Hugh Bonneville

4. **HAPPINESS**
1998, USA
Director: Todd Solondz
Actor: Jane Adams, Jon Lovitz, Philip Seymour

www.nicotext.com

1. "-Pussy, pussy, pussy! All pussy must go. At the Titty Twister we're slashing pussy in half! This is a pussy blow out! Make us an offer on our vast selection of pussy! We got white pussy, black pussy, Spanish pussy, yellow pussy, hot pussy, cold pussy, wet pussy, tight pussy, big pussy, bloody pussy, fat pussy, hairy pussy, smelly pussy, velvet pussy, silk pussy, Naugahyde pussy, snappin' pussy, horse pussy, dog pussy, chicken pussy, fake pussy! If we don't have it, you don't want it!"

2. "-Online sex is not cheating.
 -How do you figure, 3 o'clock in the morning, your wife and kids are sleeping upstairs and your downstairs in your den fucking some bimbo out in cyber space.
 -First of all, we're not fucking we're typing, and second of all, and this is my taking umbrige, Charline is not some bimbo.
 -You're right she's probably a stock broker named Ralph pretending to be some bimbo named Charline."

3. "-I can't believe Roberta's a prostitute.
 -Roberta's not a prostitute.
 -I saw this thing on television about this woman who turned tricks in the city from nine until noon, then went shopping all afternoon. It was years before her husband found out about it. Oh, my God, I've heard that nine out of ten prostitutes are lesbians.
 -Don't you think I would know if my wife was a lesbian?
 -Why? You didn't know she was a prostitute!"

ANSWER >

1. **FROM DUSK TILL DAWN**
 1996, USA
 Director: Robert Rodriguez
 Actor: Harvey Keitel, George Clooney, Quentin Tarantino

2. **THE STORY OF US**
 1999, USA
 Director: Rob Reiner
 Actor: Bruce Willis, Michelle Pfeiffer, Tim Matheson

3. **DESPERATELY SEEKING SUSAN**
 1985, USA
 Director: Susan Seidelman
 Actor: Rosanna Arquette, Madonna, Aidan Quinn

1. "-This could be a real positive experience for you guys. There's a
 whole world of possibilities to discover when we realize we don't
 need TV to entertain us.
 -Huh huh, he said anus.
 -Entertain-us, anus.
 -Did you hear a word I said?
 -Yeah, 'anus'."

2. "-Now, if I'm gonna be killed on the job, it's gonna be by a fucking
 bullet, not a fucking bus. Now turn this fucking car around and
 let's get back on your fucking patrol.
 -You may have a limited vocabulary, Ted.
 -Fuck you!"

3. "-You know, I think you're a very special unit.
 -That's sweet.
 -I hope we get to know each other better.
 -Yeah, me too.
 -Do you swallow?"

4. "-Whoa... whoa... whoa... stop right there. Eatin' a bitch out, and
 givin' a bitch a foot massage ain't even the same fuckin' thing.
 -Not the same thing, the same ballpark.
 -It ain't no ballpark either. Look maybe your method of massage
 differs from mine, but touchin' his lady's feet, and stickin' your
 tongue in her holyiest of holies, ain't the same ballpark, ain't the
 same league, ain't even the same fuckin' sport."

ANSWER >

1. **BEAVIS AND BUTT-HEAD DO AMERICA**
 1996, USA
 Director: Mike Judge
 Voices: Mike Judge, Tom Andersson, Van Driessen

2. **KUFFS**
 1992, USA
 Director: Bruce Evans
 Actor: Christian Slater, Tony Goldwyn, Milla Jovovich

3. **ME, MYSELF AND IRENE**
 2000, USA
 Director: Bobby Farrelly, Peter Farrelly
 Actor: Jim Carrey, Renee Zellweger, Robert Forster

4. **PULP FICTION**
 1994, USA
 Director: Quentin Tarantino
 Actor: John Travolta, Samuel L Jackson, Uma Thurman

1. "-Agent Browning, can you shed some light on what's been happening here?
-Well, it looks like some goddamn stupid motherfucker has decided to take some poor innocent fucks hostage, and we've been out here all fucking night trying to deal with this goddamn situation, but there hasn't been a fucking break yet. But we're sure as shit hopeful that everyone will be safe, and that this motherfucker, or motherfuckers as the case may be, be brought to fucking justice. How's that?"

2. "-I think you're all fucked in the head. We're ten hours from the fucking fun park and you want to bail out. Well I'll tell you something. This is no longer a vacation. It's a quest. It's a quest for fun. I'm gonna have fun and you're gonna have fun. We're all gonna have so much fucking fun we'll need plastic surgeory to remove our godamn smiles. You'll be whistling 'Zip-A-Dee Doo-Dah' out of you're assholes! I gotta be crazy! I'm on a pilgrimage to see a moose. Praise Marty Moose! Holy Shit!"

3. "-It's very pretty.
-You know, just simple lines intertwining, you know, very much like - I'm really influenced by Mozart and Bach, and it's sort of in between those, really. It's like a Mach piece, really. It's sort of...
-What do you call this?
-Well, this piece is called 'Lick my love pumps."

4. "-You're a powerful sexual being, Ernest.
-I am?
-Yes, you are. If I never told you before, it was because I wasn't the sort of girl who could say the word "sexual" without blushing. Well I can now. Sexual... sensual... sexy... sex... sex... sex..."

ANSWER >

1. ALBINO ALLIGATOR
1996, USA
Director: Kevin Spacey
Actor: Matt Dillon, Faye Dunaway, Gary Sinise

2. VACATION
1983, USA
Director: Harold Ramis
Actor: Chevy Chase, Beverly D'Angelo, Anthony Michael Hall

3. THIS IS SPINAL TAP
1984, USA
Director: Rob Reiner
Actor: Michael McKean, Christopher Guest, Harry Shearer

4. DEATH BECOMES HER
1992, USA
Director: Robert Zemeckis
Actor: Meryl Streep, Bruce Willis, Goldie Hawn

Index

Index

Index

Index

Index

Index